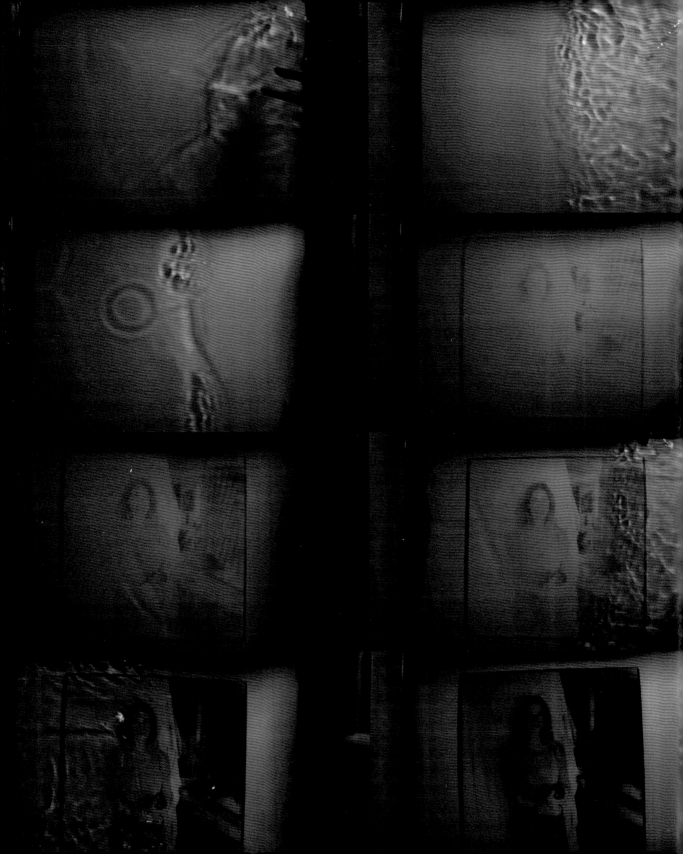

FROM DARKROOM
TO DAYLIGHT

Harvey Wang

edited by
Amy Brost and Edmund Carson

Daylight

Cofounders: Taj Forer and Michael Itkoff
Designer: Ursula Damm
Copy editor: Elizabeth Bell

© 2015 Daylight Community Arts Foundation

ISBN 978-0-9897981-8-1

Printed in China

Daylight Books
E-mail: info@daylightbooks.org
Web: www.daylightbooks.org

CONTENTS

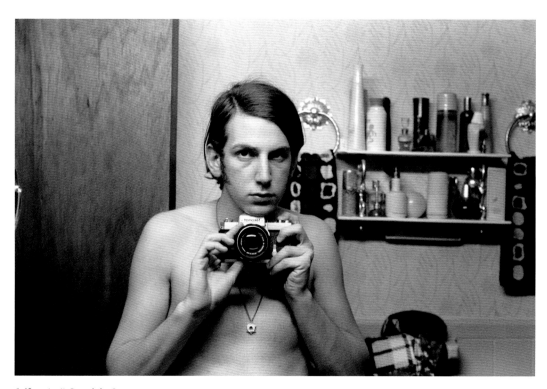

Self-portrait, Rosedale, Queens, 1973

INTRODUCTION

I began taking pictures for real at the end of middle school. It was unusual to walk around with a camera in the Queens, New York, neighborhood where I lived, but from age 15, I was never without my Nikon camera. I would shoot black-and-white film and develop it in the basement darkroom of my house.

I loved the ritual of developing film and making prints: removing the exposed film from its metal canister, spooling the film onto reels in darkness, measuring the chemistry, and pouring each chemical into the developing tank. After the film was in the fixer, I could open the tank and see the negative images on the film for the first time.

When the film was dry, I'd cut the negatives into strips and make a contact sheet. The negatives were placed in an envelope, and a number was assigned to each envelope. The same number would be put on the corresponding contact sheet, and they were stored in boxes. Every year, a new box was added, and the contact sheets became a diary visually documenting my passage through the years.

For over 25 years, I exposed black-and-white film, developed it, and made contact sheets and prints.

I stopped adding to this multi-decade collection of sequential envelopes in about 2000, when I started to shoot more color, and eventually to shoot digital.

Some time later, I realized something had changed about my relationship to photography.

I wasn't sure that the new ways of working suited me. I wondered if other photographers' worlds were turned upside down when they stopped mixing chemicals and isolating themselves in the dark.

—Harvey Wang

This book is the product of my interviews with photographers and important figures in the field of photography conducted from 2008 to 2013. All the text in these pages is excerpted from those interviews and from correspondence that followed.

Harvey Wang's darkroom, Brooklyn, New York, 2012

THE
DARKROOM

I remember my first experience in a darkroom, of watching an image come up in a black-and-white developer tray, and it is astonishing.

—Alison Rossiter

When I saw that print come up in the developer, I said, "I have found my life's work."

—Alfred Gescheidt

Not a unique story. You see a print come up in the developer, and you get hypnotized by the magic, and you just want to keep doing it.

—Sid Kaplan

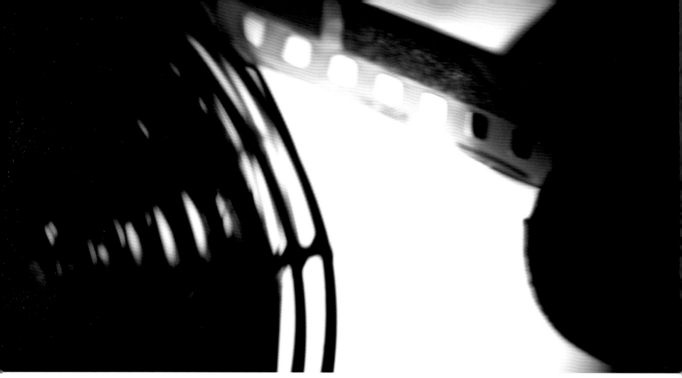

Reel with film after development

ADAM BARTOS:

One of my great influences was *Blowup*, Antonioni's movie. Nothing beats that fantastic sequence of watching the image come up on the paper in the darkroom, and then the way he kept enlarging and rephotographing that area, blowing it up optically, chemically, to try and discover the truth of what the image contains. I mean, punching the "plus" button on your computer? No, it's not as cool.

I started a few years ago to photograph darkrooms when I heard about one that was closing, and all of a sudden, it clicked that—hmm, maybe I should go and make a record of that (*Darkroom*, Steidl, 2012). The darkroom is a metaphor for so much about art and craft, and it's the architecture most photographers have shared, until now. There are aspects of the darkroom that are instantly familiar to us, the sound of the water running, the humidity, the clocks, the music we play in the dark....

PLATON:

The darkroom is the beginning of everything. You're locked away. It sort of isolates you from the world around you, in a way that the computer screen does not. And it forces you to commit 100 percent to what you're doing. There's no point in doing anything else when you're in the darkroom, because it's dark. It's just a hint of red light, and that is it. You are there to print.

SALLY MANN:

I go in the darkroom, I close the doors, and there's the soothing sound of the water, that little gurgle, because you're always washing. And that forgiving yellow light.

Oh, it's so calming. It's really good for me to be in the darkroom. You're by yourself, no one dares walk in on you. It's perfect peace.

JOHN COHEN:

I enjoyed the process of being out in the world shooting, and then spending a lot of time in the darkroom. Really living with each print, and spending a lot of time on it, not just making it darker or lighter so much as discovering what meanings were in there.

JEROME LIEBLING:

Certain truths were given to you as a student. One was that you really created that image. The paper was given to you, but you could somehow, with your skill and sense of spirit, imbue that piece of paper with your own sense of what was there.

GEORGE TICE:

When I'm making a print I'm making a finely crafted art object. I'm not just making an image. I like my solitude. I live alone, I've been married three times, I have five children. The darkroom is a place where you can think, and concentrate on what you're doing because there are a hundred things you can do wrong, and you're trying to get them all right.

After developing my film and printing a contact sheet, I make a proof print. I have a big bulletin board downstairs where I tack prints up. Then I'll decide what's in, what's out. After printing something the first time, I can usually improve on it somewhat the second or third time.

JEROME LIEBLING:
We all know the running and jumping that we do when we dodge, and we only have two hands, and you want to open this, and change that, and you can only go so far [before the time is up], and then you quit.

DAVID GOLDBLATT:
When there's light hitting that sensitized paper, you've got a limited time in which to make all the changes you want to make, all the adjustments.

JOHN COHEN:
It's kind of fun, you realize, once you've seen the digital thing, that when you're up in the darkroom, you've got to move your hand and dodge and burn. You have so many seconds, and then it's over. So it's a little bit more of a performance, actually.

DAVID GOLDBLATT:
And these are the adjustments that, to me, are part of the trade. They're not the adjustments of putting trees in where they weren't, of taking people out, and putting them in, and that sort of thing. I'm talking about basic changes to the image to make it more consonant with my understanding of it.

PLATON:
It's in the printing where I really learned that your skin is different from your shirt, and your shirt is different from your boots. The more contrast I give your shirt,

the more I describe its material makeup; same with your skin, but your skin is much lighter than your shirt, so I can't treat it at these contrast levels in the same way. So I started learning to cut masks out with paper, and I would lay them on the print, and I would do about 20 or 30 masks for each print. And each print would take about three days to do.

ALFRED GESCHEIDT:
My hands are all brown, my fingernails are brown from the soups [chemicals] I was using. I just accepted it as part of the discipline. I didn't think there was any other way to do it.

RICHARD SANDLER:
Every print is different. You cannot possibly duplicate them. Every one is slightly different, and some of them are better than others, of course, and maybe you make a mistake, and out of that mistake comes something brilliant.

ALFRED GESCHEIDT:
I still think of the image coming up, and saying "Son of a bitch, I got it," or "Nope, got to go back."

Right: A negative in the enlarger (top), and dodging and burning (bottom)

Rochester, New York, 2012

MATERIALS:
The Endangered
and the Extinct

PHOTOGRAPHY IS ALWAYS CHANGING

Eric Taubman

It starts in 1839 with the daguerreotype, which is an image on silver-plated copper. That was really the first process, around the same time as the calotype process by Henry Fox Talbot, which is a paper negative process. Very beautiful, very different, and these are things that still can be done now. It's tricky, the materials are not always easy to get. But the more people that do it, the more reasons there are for manufacturers to keep the materials available. Those were the processes for the next 20 years. But toward the end of that 20-year period was a bit of an overlap with the discovery of wet-plate collodion, which came in around 1853. That was a process more geared toward the masses. At that point, many people decided that they could do photography, and there were packaged kits available. And so it was photography available to a larger world. Its heyday was from the early 1850s through about the early 1870s.

The wet-plate collodion process is a process using the substance collodion, which is also referred to as gun cotton, or nitrocellulose. And it's basically a glue, or a binder. Collodion comes from the Greek word for glue. And it's a glue-like material, or syrupy material that you pour onto either glass or tin. The wet-plate collodion process is really related to three types of products: the tintype, which was a positive image on tin; the ambrotype, a positive on glass; and then a glass negative, for printing.

The wet-plate collodion process existed, in some form, right through the 1930s. Because it was an instantaneous process, there was a place for it much after its heyday, 1870. By then, dry plate came along, and that was kind of a revolution, because you didn't need to shoot the plate wet in the camera, or have your whole darkroom with you wherever you went to shoot. It was on glass, but you could shoot your picture and then take it back to the darkroom, or send it out to somebody to develop. No muss, no fuss. That's the beginning of that. And that was the precursor to film, which was flexible-base roll film, multiple exposures on a roll. The rest is history. We all kind of know it: black-and-white roll film, color, Kodachrome came in, during the 1930s, 1940s....

Daguerreotype from the collection of Eric Taubman

THE END OF KODACHROME

Jeff Jacobson:
Kodachrome, I think, was the grandest manifestation of color in film. There is nothing quite like looking at a Kodachrome slide. I mean, it's really beautiful to sit in a dark space and project slides.

Alex Webb:
Kodachrome has a kind of rich smoothness, a sense of depth, both depth of color, and depth in terms of the sort of three-dimensional feel of it.

Jacobson:
Kodachrome is a unique process. It's a far richer color film than anything else that's ever been made.

Webb:
It has particularly deep blacks, particularly deep reds. It has a kind of punchy emotionality.

Jacobson:
Kodachrome also defined a whole era of how Americans thought about their life. People looked at their lives through Kodachrome, especially in post-war America, and it really defined, through the '50s and the '60s, what American life looked like. I started using Kodachrome in the late '70s. I just realized pretty quickly that there's nothing else like it.

Webb:
When I came to working in color in the late '70s, really, in trying out different color films, the only film that made sense for me at that time, in 35 millimeter, was Kodachrome. With Kodachrome you'd have your cartridges of film, and you'd ship them directly to some Kodak facility, or drop them off at some camera store. Then the slides came back to you in yellow boxes.

Jacobson:
There's something about opening that box, and laying those slides out.... For me, it was a magical moment.

Webb:
But usually the magic disappeared incredibly fast.

Jacobson:
And I always would just look at them first. I'd lay them out on a light table before I'd project them. I would start editing from a light table. I still do. Unfortunately, they're not in the little yellow boxes anymore.

Webb:
There was something about the time it took, physically, to go through those, through the transparencies, and back through them. This process of making a first cut, putting part of it away, and then making another

18

cut, and another cut, and slowly whittling it down, was very satisfying in many ways. I certainly was worried for a number of years about the possibility of the disappearance of Kodachrome, because they had been talking about it for years, and it was a slow process. I remember Jeff [Jacobson] calling me one day, and he said, "Alex, you won't believe where I am." And I said, "No, where are you?" And he said, "I'm in—I'm in Parsons, Kansas. I'm at Dwayne's Photo!" you know? And then he said, "You know, it really just looks like a little mom-and-pop photo shop, but they have all this Kodachrome coming in from all over the world."

Dwayne's Photo was the last processor of Kodachrome and processed the final roll in 2010.

Jacobson:
The market for Kodachrome clearly collapsed.

Webb:
The last major project that I completed in Kodachrome was *Violet Isle* (Radius Books, 2009), the Cuba book that Rebecca [photographer Rebecca Norris Webb] and I did together. In some ways, it's kind of appropriate that Cuba be the last Kodachrome project. You think of Cuba as sort of associated with the '50s and '60s, and of course, Kodachrome is a film that one associates with that era.

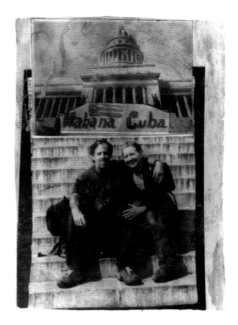

Portrait of Alex Webb and Rebecca Norris Webb, Havana, 2003, by a Cuban photographer whose 1903 camera uses a paper negative (Courtesy of Alex Webb)

Jacobson:
For me, the end of Kodachrome is dovetailing with a period in my life where I've been forced to face my own mortality, because I had cancer, and went through chemo, and then about a year later, Kodak discontinued Kodachrome 200. So the two events are related for me, but the preciousness of the remaining Kodachrome just highlights the preciousness of any remaining time I have in photography. So in that case, if they had to end Kodachrome, this was a pretty good time in my life for them to end it. It has heightened my awareness of it, I think, in a creative way, and all things end. The only constant thing in the universe is that it's going to change. I'll figure something else out.

PHOTOGRAPHIC PAPERS

Paul Messier:

I'm an art conservator specializing in photographic materials. In the middle of the 19th century, photographic papers were not commercially available. If you were a photographer and wanted to make a print, you had access to information, but you were pretty much on your own in terms of acquiring the materials locally to make a photograph. So you would start with a plain piece of paper that you would sensitize and process yourself. Relatively soon thereafter, around the mid to late 1850s, and certainly by the 1860s, a lot of different manufacturers of photographic papers appeared. And these would be albumen papers, the papers that were used to record the American Civil War, for example. And those were by and large all commercially prepared papers. For silver gelatin, the black-and-white papers, you really don't see those appear until the latter part of the 19th century. George Eastman really believed in them, except the trouble was that he was one of the few people who really believed in them. They were very hard to use and they were not widely embraced by either amateur or professional photographers.

Photographic paper boxes from the collection of Alison Rossiter

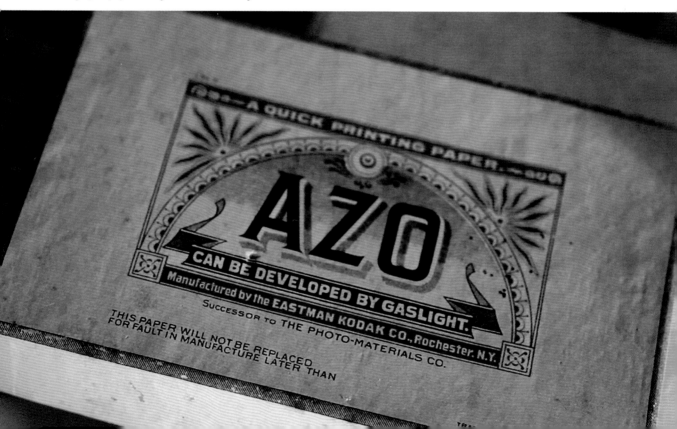

It was really the introduction of Velox by the Nepera Chemical Company, in the latter years of the 19th century, that pushed it over the top. It was a paper geared for amateurs primarily, but it had the right combination of all kinds of different factors to make it a commercial success. It was not too fast, and that was one of the big problems with the early-generation gelatin silver papers. They were too fast and they required a photographic darkroom. Printers didn't print in the darkroom in the 19th century; the papers weren't fast enough. You could very easily print in a well-lit room, and check the progress of the print as it developed without exposing the paper and ruining the print. So those papers were too fast. Velox was right. It was the right combination of speed and enough attributes of the earlier generation papers, but it was also forward-looking enough technologically, and it was a huge success. And George Eastman bought the company and popularized the paper, and soon thereafter many manufacturers started getting involved.

By the mid-teens, late teens, we start getting away from pure contact printing, and photographic printing really then fully moves into the darkroom, and you start getting enlarging papers that are specifically designed both for professional use and for amateur use. At that point you start to see the diversity of papers come in. Really around 1915, 1917, you start

seeing more manufacturers in that space, you start to see them competing. And by 1925, you have this incredible diversity available to photographers that probably only increased until around World War II. The photographic manufacturers kind of devoted their efforts more to the war effort, devoted their innovations to making things faster, a little bit cheaper. And then color came in after World War II.

In retrospect it's easy to identify that as the beginning of the end for what we conventionally know as black-and-white papers. The heyday was between the wars; that period really was the peak for the diversity of the different papers, what papers were out there. Today, we are down to a very few manufacturers and a fairly limited range of surfaces, textures, and paper varieties.

The first papers that I bought were from a little camera store in a small town in Massachusetts that was going out of business. They had a lot of Agfa sample books from over the years, and I thought, we need this in conservation. We need the materials-based understanding of 20th-century photography, and yet we were actively losing it, really quickly, with the transition to digital.

I have 5,200 or so catalogued pieces of photographic paper. But what was available at the peak—I would really love to

know myself, because it would give me a benchmark that I could kind of collect against. Anytime I get a feeling that the diversity cannot increase, it increases exponentially. I discover different manufacturers that might have come and gone. I discover a sample book that shows me that I only have maybe 10 percent or less of a manufacturer's papers for a certain period. So it keeps opening up for me how diverse it was, and I wish there was a census of, at the peak, how many manufacturers there were, how many brands, how many surfaces that were put out onto the market. I really don't know.

It's really difficult for anyone looking at a sample book to understand what it's about. They're going to see goofy images of very posed models and funny-looking dogs. And that's not what you should be looking at. What these are meant to illustrate are all the different attributes of the papers, the physical attributes of the papers, the texture, the gloss, the color—trying to help a photographer make a good decision. And also trying to help a photographer sort out this hugely diverse world. When we think of a black-and-white photograph, we sort of conjure up this monolith, right? It's a black-and-white photograph. It's ubiquitous, right? It's everywhere. But within that universe, there really is this language that we don't really know how to speak anymore.

Robert L. Shanebrook:

I worked at Eastman Kodak Company from 1968 to 2003. Prior to my time at Kodak, I don't know the exact numbers, but Kodak in the 1940s and '50s probably made 10 or 15 different emulsion types. They were Medalist, Kodabromide, Illustrator Special, Azo, and so on. Those are just the emulsion types, all of which were graded, meaning they were able to provide a range of contrasts. In the darkroom the photographer chose the desired contrast, ranging from zero to perhaps five or six. In addition, Kodak had large numbers of different paper surfaces. The paper surfaces were made in two very different ways. One, Kodak would do things to the pulp so that the paper pulp was actually different depending on which type of paper they wanted to make. Two, they would emboss it, either by changing the rollers or by using a different blanket on the paper-making machine, to give a different pattern on the surface. So the photographer could choose from different textures. There were smooth surfaces, matte surfaces, as well as different kinds of tweeds, or silk or embossed patterns. The surface selected depended on the application and what went well with the photograph's subject matter. The surfaces were identified by letters. There were more than 26 surfaces, so some of the letters were reused after they had been retired for a few years. Back then, there was a wide variety of papers available. That started to go away in the '50s, as

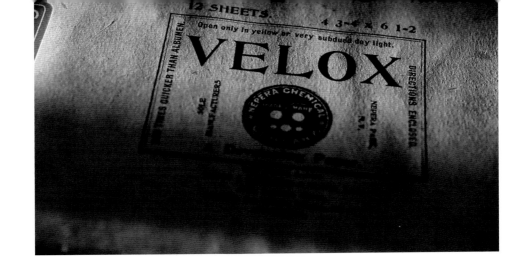

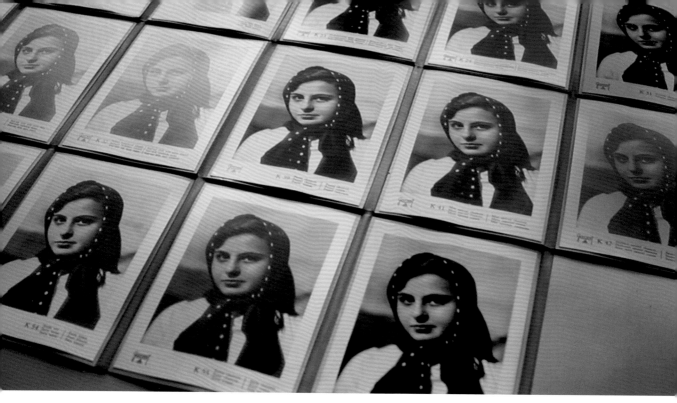

Gevaert sample book from the collection of Paul Messier

black-and-white paper volume started to go down and color paper started to go up.

Alison Rossiter:

I have been a photographer since 1970. I woke up one morning and realized that materials were disappearing so quickly, and I wanted to use an old 5x7 view camera I had. It dawned on me that I couldn't buy any film for it new, and this was terrifying. So that sent me to eBay for the first time, and I decided that I would collect expired sheet film. Initially I wanted to use it as a photogram project, but I started buying whatever film I could find. One person from North Dakota sent me the contents of an old studio, 8x10, 5x7 film, and in it was one box

of a Kodabromide paper that had expired in 1946, and I thought, well, let me test it. So there were 250 sheets inside the pack that had never been opened, and so I pulled one sheet out from the middle of that pack and sent it through the chemistry. If it was viable as a printing paper, it would turn out white at the end of the process. I processed the sheet, and what I saw amazed me. It looked like someone had taken graphite and rubbed it over a rough paper surface. It was the failure of the emulsion. The silver halides couldn't stay light sensitive for all those years, and this very simple image...to me, it was just astonishing. And I knew from that moment that there was something to go look for in expired

papers, found work that had been latent. These are latent images that are made by atmospheric damage, or light leaks when opening the package, mold, shock, all sorts of things. So really it began with an accident...just by chance. I was buying film and someone sent me paper.

Photographers who came later in the century have never seen what [photographic paper] was available. I'm completely in awe of what was made before, and wish that I had been able to use them when they were still viable printing papers. There were so many choices: warm tones, warm tones on a cream base, warm tones on a cool base. The colors were astonishing. The contrasts were amazing. I was sad that these things were gone, sad to find out that so many beautiful materials existed long before I was a photographer, and so those are gone to me. And then the sadness disappeared, and I realized that I'm using these with a new purpose.

My expired-paper prints are titled with three bits of information: the type of paper, the date it expired, and the date I sent it through the chemistry. So it will be *Acme Kruxo, exact expiration date unknown, circa 1940s, processed 2012*. That will be it. And it's a long one, it's a real mouthful of a title, but I want that to be all the information. It tells you everything about the paper, particularly the time span between expiration date and processing date. That way, comparisons can be made, and even if

there was nothing but black—black sheets framed all the way around the room in an exhibition—the blacks would be very different, the sizes would be very different, and they would be individualized by their titles. They need nothing more from me.

These prints do point to the history of photography, do point to a time period that is so far behind us, but we're getting to see it. Some of it's like finding dinosaur DNA. It shouldn't be here. All of these old papers should've been thrown out a long, long time ago. That they have survived is incredible.

Howard Hopwood:

We are virtually the last man standing in the black-and-white paper market.

I've been with Ilford for 39 years. I've become chairman of Harman Technology. The company was established in 1879 by a gentleman called Alfred Harman, and he moved to a plant in Ilford, which was in the middle of the countryside in those days, in 1879, and hence the name of the company.

Well, the strategy of Ilford was quite clear in the late '90s, particularly. The idea was that we would use the black-and-white photography business, which was profitable, and also was relatively stable. It had been declining since, I think, 1960, so we'd gotten used to the idea of it declining between 5 and 7 percent a year; that was what we expected,

and all of our plans were built around that. Inkjet offered us the opportunity to get a growth dimension to the business, and so the idea was that we would grow inkjet as black and white declined, and then the two lines would cross; we would become an inkjet company with a small black-and-white business. It was all happiness. Unfortunately, around 2003, 2004, instead of black and white declining by 5 to 7 percent, it suddenly declined in the high 20s—25 to 27 percent—as the digital camera became easy to use, and people started to be happy with the results. So there was a big step change. And probably, the company could've withstood one year of that, but there was a second year, in 2004. And that meant that the growth in inkjet was not sufficient to outstrip the decline in the black and white. So the idea of gaining money from black and white to put into inkjet growth, the equation just didn't work anymore. So at that point, the two parts of the business became separated during the receivership process, or Chapter 11, as you call it in the US. Myself plus five other ex-managers of the Ilford Group then bought the company out of receivership, and we established a company in February 2005, Harman Technology. We used Alfred Harman's name when we bought the company. So we're now just about five years old, and they said it wouldn't last. But we saw the potential in the continuation of black and white. We're just monochrome,

black-and-white Ilford products, and we only have the Ilford brand for use with black-and-white photographic products.

When we got to the point of receivership, there were a sufficient number of people, particularly here in the UK, who had a strong belief that black and white was different. It wasn't the case of digital or analog. It was a case of these people seeing that black and white in particular gave them something that digital didn't. Anyone who sees a black-and-white picture, no matter who they are, is always astonished by how beautiful it is. One of the things that always drove us on was the fact that black and white gives you a very beautiful image, and it is not a recording of an event; it's an interpretation of an event. I think that's what made the difference to us. And so we believed that there would be a market for black and white for some time.

I remember when we bought the company...the next day, we managed to get a slot at the SPE conference [the Society for Photographic Education], in the US. I said, can I just have the first five minutes of your meeting, just to say what's happened? So I announced that we'd bought the company, and it was going to carry on. And there were actually people crying in the audience, and you think, my goodness, I didn't realize how important Ilford is to these people in education. They live and breathe it. When I came back, I said to the

other directors, "I don't think we realized that we weren't just buying a business, we were actually buying a responsibility." And I think we've tried to stick to that.

We just saw that there was an opportunity here. We thought it was wrong closing the business because we believed it was profitable, and it wasn't until after we got here and sat down around this table and said, "So now what do we do? We've bought a business here, and yes we know it and love it, but now what do we do?"—we had thought through strategy beforehand, but it was very much in a cold way—that we realized it wasn't like that. We had a responsibility.

Our commitment has always been to support the creative photographer. And that's very important to us. And so we don't just consider the black-and-white part of our business as a business—saying it's actually a mission makes it sound too grand. But we do believe that there are people out there who, without us, would now not be able to do something that they love doing, and for us, that's quite a major job.

It's very interesting that since I got into marketing, which was around, I guess, the early '80s, 1982, 1983, people have been asking me the question: How long do you think black and white is going to last? Every time, I would say, well, I think it's safe for five years. Now, we're going on 28 years, and I'm still giving the same answer, which is, I think we'll be OK for another five years. So it's a very difficult question.

Ilford's first vehicle, a Foden steam wagon, ca. 1905

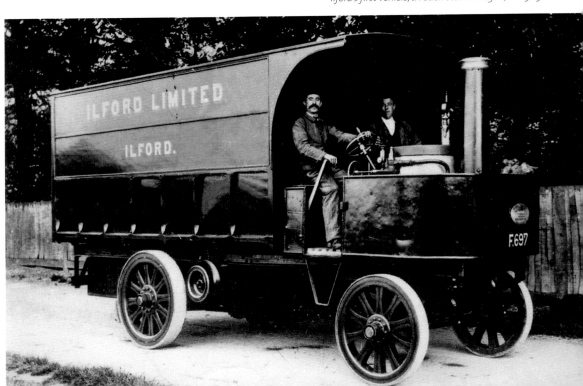

THE DIGITAL REVOLUTION IN PHOTOGRAPHY

THE INVENTION OF THE DIGITAL CAMERA

Steven Sasson

I worked at Eastman Kodak Company for over 35 years. I had the opportunity to design and build the first digital camera for consumer use, and that was in the early '70s.

I was working in an applied research laboratory, and I had a supervisor whose name was Gareth Lloyd. I remember one day, he came to me and said that he had a small project that I might like to dabble in. It was looking at these new charge-coupled imaging devices [CCDs] that had just become available. And so I jumped at the chance, and our whole conversation probably lasted less than 30 seconds. He said, "Well, get one of these things, play around with it, and see what kind of imaging performance it may have." So it was an almost nothing project. The gears started turning, and I said, well, if I'm going to do some imaging measurements, it would be helpful to capture an image, and then it would be nice if I put it in a camera form, so I could move around, take images of different things. And then I thought, well, if it's all electronic, that would be really neat, because there'd be no moving parts in this camera, and I got excited about that idea, you know, being an electrical guy.

And so I adopted a completely digital approach, not because I had any great vision, I think; it was because I really didn't know how to do it any other way. I had no idea, actually, how to build this, you understand, and because the project was really low key, basically, nobody knew we were working on it. I could fail a lot, and no one would really observe it. I had to go around and ask a lot of people about how I might do things, where I'd get parts. The camera that you see before you is all spare parts.

What worried me was the comparison to film, and the fact that you could reliably capture an image on film was a foregone conclusion. Nobody ever worried about losing an image when you captured it on film. It just didn't happen. And so tape was by far the most reliable mechanism for storing digital data—and remember, this project involved both the creation of the camera that you see here, but also a playback unit, which was based on a microprocessor development system. Microprocessor chips had just started coming out. The only way to view a captured electronic image was by using a television set. The project took about a year and during that whole time the only way to see progress was through electronic measurements, never seeing an image until the entire system was complete.

There came a day in December of 1975 when we kind of realized we had done

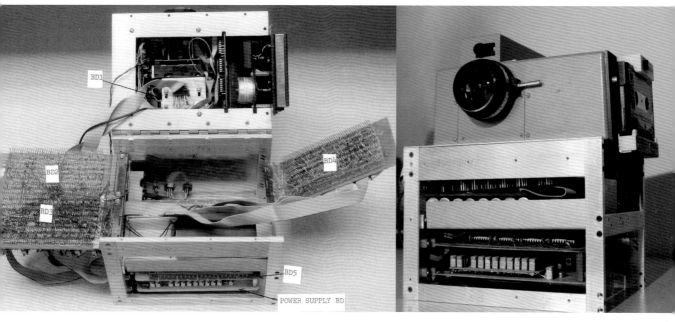

Inside the first digital camera (Courtesy of Steven Sasson and Kodak)

First digital camera prototype, 1975

all we could. It looked like data was going through. I took a tape, and I put it in the unit. We were located in just about the most unphotogenic place in the universe, our lab. So I picked the camera up and I walked down the hallway, and I found a young lab technician, her name was Joy Marshall at the time, and she was sitting at a teletype, I'll never forget this: I said to her, "May I take your picture?" And she knew us, you know, the weird guys in the back lab, so she knew we were harmless, if not strange, and she posed for a picture, and I took a head-and-shoulders shot of her. She had long dark hair, and there was sort of a white background. So I took the camera up, looked through the viewfinder, and I clicked it.

First click turns the power on. You had to wait a second for the CCD to clear after first activating it, and the second click would actually capture the image [a 50 msec exposure]. The tape would start to turn as the captured image was being recorded. That's how I knew it was working. After taking the picture, I walked back to the lab. Jim Schueckler, a key contributor to this project, came with me, and Joy followed us. After the image was recorded on the tape, I popped it out of the camera, put it in the playback unit, and about 30 seconds later, an image popped up on the screen, and what we saw was the silhouette—her silhouette and hair, you could see. You could see the white background, but her face was complete frozen static, completely

unrecognizable. Now we were very happy to see this distorted image, because we knew there was a high probability of not seeing anything at all!

Now Joy, who was standing behind us looking over our shoulder, was less impressed with the image, and she said, "It needs work," turned around and walked out. I'll never forget that. What had happened was, when I designed the playback unit, I reversed the order of the bits. We figured it out, and we actually switched some wires—that was cheaper and easier than reprogramming the computer—and then the image popped up, and it was a big thrill. We actually saw it; it looked good. Well, this first array was a matrix of 100 by 100, so that's 10,000 pixels, or .01 megapixels in today's parlance. Now, today's cameras are typically 10 megapixels, 12 megapixels.

Kodak was working on this years and years ago. We didn't know exactly where it was going to go. We clearly had a very successful business model with film. You know, we take for granted the Internet today, or photographic printing on a desktop. None of that existed back in '75, or in '85. I guess you have to remember that when you're an inventor, the whole world's inventing along with you, and your idea may take its final form in a world that you can't even predict, because other people are doing interesting things.

Playback unit and television set for viewing captured electronic images (Courtesy of Steven Sasson and Kodak)

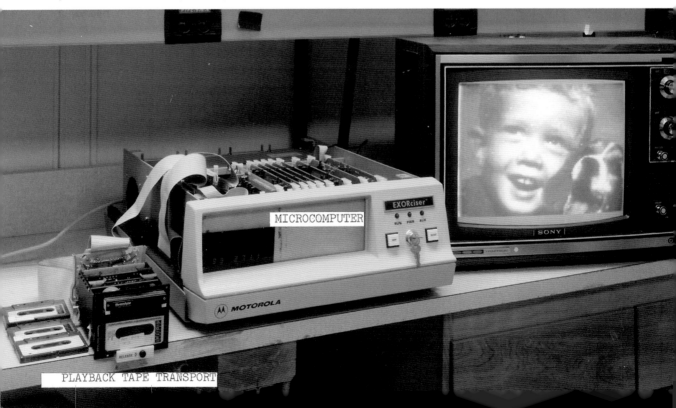

THE INVENTION OF PHOTOSHOP

Thomas Knoll

I've been a longtime amateur photographer. I did a lot of black-and-white photography as a teenager, doing all the developing, the processing. I spent a lot of time in the darkroom, trying to make prints and trying to solve the classic problem of getting the whites to be white without being blown out, and the blacks to be black without being blocked. And the problem is, when you're doing a print in a darkroom, you really don't have direct control over the whites or the blacks. What you have is control over the overall exposure of the midtones, which sort of drags the whites and the blacks up and down together, and you have control over the contrast, either through different grades of paper, developing time, or variable-contrast paper. But that's basically spreading out the whites and the blacks away from the midtones. What you really want is to control the whites independently and the blacks independently. So I understood the struggle of trying to adjust an image.

And even back then, I thought, I'm sure if we could do this on a computer, it would be a lot easier, because you could control things independently. I actually had little tables and charts that I worked out for the darkroom, exposure and contrast, to try to unravel the two factors in order to adjust each parameter independently by adjusting simultaneously the contrast and

exposure to only move the blacks and not move the whites. When I was working on Photoshop, one of the first things we tried to do was a basic tone control where you could adjust the whites and the blacks and the midtones. And I remembered my struggles in the darkroom. So I invented the levels dialogue, where you have one area where you can see where the data is in the image, and you have one slider that controls where the whites are, and one slider that controls where the blacks are. It was a very direct manipulation of the things I had struggled with in the darkroom.

Working on my Ph.D. at the University of Michigan, I was doing some research in computer vision, and the first step of many computer-vision algorithms was image processing. So I wrote a bunch of little tools that did basic image-processing steps. Simultaneously, my brother [John Knoll] was working at Industrial Light & Magic, and he decided the next big thing in special effects for movies was computer graphics. I suggested to him that he use some of these tools I developed. So I shipped off my tools to him, and he kept on requesting more and more tools. So I combined them into a single application, and after a couple months of this, he had the idea maybe we could sell this thing, and eventually found Adobe to publish it.

At that time, the ways of getting stuff into the computer and out of the computer were pretty primitive. So the only viable path for Version 1 users was very early scanning technology, either slide scanners or flatbed scanners. A 300 dpi flatbed scanner cost about $7,000 at the time of Photoshop 1.0. And then to get images out of the computer, the only real practical way was to do four-color separations. You could get four-color separations on film and then do a printing press run. So the initial commercial application of Photoshop was for the graphic artists doing stuff for production in magazines or newspapers.

There are many features in Version 1. It's fun to look back on it and play with all the tools and see how, actually, quite complete it was. And it had all the basic darkroom facilities, including dodging and burning. We had a dodge-and-burn control in Photoshop 1. It had quite sophisticated masking controls, which you could do in a darkroom in an analog way. I never did that personally, creating unsharp masks or such. But a lot of the digital techniques emulated some sort of very advanced darkroom use.

But Photoshop also contained things that were completely different than what you could do in any darkroom. For example, you have a hue saturation control that can spin the hue wheel completely around 180 degrees, which I don't really know how to do in a darkroom without inverting the tones at the same time. So you can do some very digital-only things in Photoshop 1.0, but lots and lots of the basic darkroom adjustments were

already available in Version 1. There are a lot of versions over the history of Photoshop. The seminal version is Version 3, in my mind. We did Version 2, and then Version 2.5 added Windows support, so that was the big feature there. But Version 3 added layer support. So it introduced the model that we still use today for compositing and doing nondestructive adjustments, where you can create a layered document and then move the layers around, and it saves all that information. So Version 3 is my favorite version of Photoshop, because it added that hugely important feature.

The idea of layers actually came from the movie industry, not photography. It was from animation. Because that's how animators have been working for a very long time. They would paint individual characters on pieces of acetate, and then they would have a background piece of acetate; and they could place the characters on the acetate, and they could like, draw on new pieces of acetate where the character moves slightly, but they could put it on the same background. So they had this stack of clear material with paint on it, which is the exact analogy of layers, because you can add anything on any layer, and part of

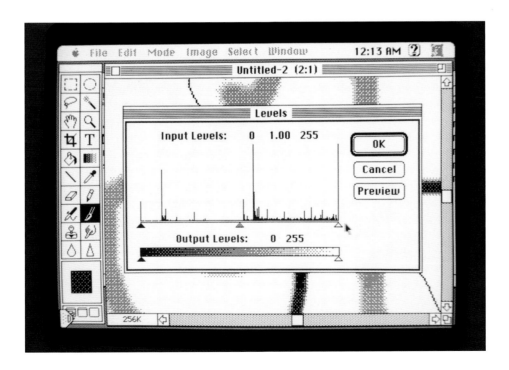

the layer can be opaque or transparent. So that's the model we based layers on.

And everything in Photoshop, somebody had done something similar sometime in the past. So often it was on a very expensive system, or it was done analog. All we did was do a digital version of it. But it seemed very incremental to us at the time. But people coming into it, seeing it for the first time, it seemed magical to them.

Photoshop was in a very good position for a lot of technology advances, and we were in the right place at the—before the right time, even. There were several big waves of technology that moved Photoshop into new application areas. The first big wave was the World Wide Web. People suddenly needed to produce lots of photographs and reproduce them at small size for display in web browsers. Then the real breakthrough technology for fine art photographers was the inkjet printer. Because suddenly now you could print a high-quality photograph one off, not do separations and do a whole press run of thousands of photographs, but you could suddenly print out single photographs. So photographers could do a high-quality scan on their slide scanner, and then do a print of that photograph. It opened up a whole new work flow for the professional photographer. Then things totally exploded when the digital cameras became practical—and Photoshop predates all three of those things.

There are a couple of times when I realize the impact that Photoshop has had. When you walk into a bookstore, one of these big chain bookstores, nowadays, and you see the Photoshop section of the books, and there's often three or four shelves of books of people trying to teach people how to use Photoshop. And that's mind-boggling to consider that I started that program that everybody's struggling to learn, and it's so popular that every bookstore in the country basically has a little section on this particular product. And the other time that reminds me is when I'm watching a random movie or TV show, and they use the word Photoshop, usually as a verb. Creating my own word in the English language is kind of cool.

The original reason we did Photoshop was because it was really fun to manipulate images on a computer. We weren't really thinking of any practical uses of it at all, but as soon as people saw that they could manipulate images very easily on a computer, they developed uses. And every time I watch really good users using Photoshop, I'm amazed by the variety of things they can do with it, that I would never have thought of when I was writing the program.

I'm still the first name on the Photoshop splash screen. Fortunately it's just a name and it's not a face, and I can live a fairly anonymous life most of the time.

THE DECISIVE MOMENT BECOMES *DAY TO NIGHT*

Stephen Wilkes

The *Day to Night* series started, really, as a sonnet or love poem to New York City. I've always been fascinated by the energy of the city, and the pulse of New York City. If you look at the history of photography, there have been specific moments when there were these shifts, where the way we look at the world changes through the technology of photographing, and what happens in a camera. If you look at Muybridge and you look at the work of Harold Edgerton, those were sort of moments where suddenly, our perception of what a photograph is, changed. We've gotten to a point with technology now, with Photoshop, that we can really change the way we look at a single photograph. Suddenly, a single photograph can change time, within one frame. And so that concept was very exciting to me.

On location I'm just scanning very, very specific areas, looking for moments. I'm taking photographs for 15 hours. I sit and I photograph everything that I see. So every little detail, every little moment that you see in my photograph, is something I've consciously taken. It's only upon taking all those images that I look at them, and I study them, and I edit them down from, say, 1,400 photographs to 50 of the best moments from the morning, midday, late afternoon, and evening. And then, working with the retoucher, I put the images together. What I love about the work is that you don't feel the hand. You do not sense the fact that I'm changing time, immediately. It's only upon closer examination that the photograph begins to reveal the fact that you're actually seeing these wonderful moments that happened at a very specific time, during that day and into the night.

I think as an artist today, anything you can imagine, you can create. That's an amazing statement, really, if you think about it, as a photographer, that you can do things that you never dreamed about being able to execute before. Now I want to go in and explore this next dimension of where— where can still photography go?

Stephen Wilkes in Washington, D.C., January 21, 2013 by Alex Abdalian (Courtesy of Stephen Wilkes and Alex Abdalian)

NEW REALITIES

Ruud van Empel

I actually completely stopped taking photos during the '90s, because it didn't interest me and it took too long, and that interest revived when the digital camera came. I was very happy when the computer came and Photoshop came. I remember when I saw it the first time, I was really amazed that I could do everything right there. I couldn't sleep anymore, from that moment on.

I bought my computer in 1995 and started doing Photoshop. The first idea I had was that I wanted actually to make a picture completely like reality, but one that's completely montaged. I wanted to control the image completely. I wanted to create my own people. I had so many ideas coming up of what I could do, suddenly.

What I do now is I make a sketch of the idea, basically, that's just the simple idea. And I take all kinds of photos, and I'm not sure if I'm going to use them, but those things I never know at first. So I have a few ideas of what I want to do, and work with that, and start from there. But how it looks in details is something that arises during the process, when I'm making it. If there is a person in the image, I start with the face first. That's the most important part, also the most difficult part. That could be like 100 or 200 layers, itself. The mouth, the lips—the mouth can be like 20 montages. So when that's done, I make it one layer, and then I start on the body, and that could be also like 100 layers. When that's finished, I start to do the background. Then, again, you have a few hundred layers. And sometimes it doesn't work out. So I have to do a few different backgrounds or change the idea or change the whole composition. So sometimes I'm working for months, and I end up with no results. That's possible. It happens. What I do, when it's completely finished, the image, I put a grain all over it before it's printed. So that brings everything together. I think because of the digital possibilities, you want to do different things. That goes for me, because you can create so many things. I wouldn't be doing this, I think, with an analog technique. I can really make things realistic in the way I had imagined them to be. It's inspiring.

Left: Ruud van Empel manipulating his work in Photoshop (top), and the artist in his studio in Amsterdam, 2010 (bottom)

ON PHOTOSHOP

Richard Benson, Mark Bussell, John Cohen, David Goldblatt, Jerome Liebling, Platon, Taryn Simon, and Stephen Wilkes

BENSON:

I think Photoshop is a tremendous, tremendous tool. It's a digital Swiss Army knife, and you can have stuff sitting on your desk and chop it up and leave it there. So, to me, it's this incredibly versatile tool.

WILKES:

It's like being a writer and never having had a thesaurus, and suddenly, somebody's given you this wonderful tool to have all these other words, so you can express yourself in a much deeper way.

GOLDBLATT:

On the computer screen, if I want to burn in or hold back tiny details, or bigger details, I can do so very selectively. The rest of the image is quiescent. Nothing is happening to it. It's simply there. Whereas in the darkroom, of course, it's accumulating light. So, if I have, as in one photograph, I think there must be about 12 pairs of eyes under a midday sun in Africa, I can go to each one of those eye sockets, if I have to, and lighten it or change the contrast within it.

COHEN:

I've done a little bit of Photoshop and all that. I know the things that you can do. You can work much, much slower on a print.

LIEBLING:

With the digital, you could stop and say, hey, OK. Now leave it, and we'll come back. I've gone back to the negatives and just found such riches.

The thing that I object to with digital is Photoshop. I think if you want to make pictures, you want to be a painter...well that's fine, go ahead and do it, but don't call it photography. Photography meant there was a response to the fact of life. [With Photoshop] what you're saying is, I don't really need the world; I can make the world. And artists, painters, have been doing that for many, many years. But then I go back to that essence that I thought photography as mirror image was very important and special.

SIMON:

In many ways digital is closer to painting than it is to photography, because you can keep going back to the work over and over again. You can keep adding and subtracting—and returning to it for changes. It can be visited again and again, as one would a painting. It's more handmade, and less about the moment.

In my work, I use Photoshop in a limited form—mostly to allow a digital image to look like film. Endless hours are

wasted trying to achieve what I formerly achieved on film.

BENSON:

When you manipulate pictures on the computer, you have as much time as you want to do what you want, and it's absolutely wonderful. And in the darkroom, you might have been strapped with time a little bit, but the real problem of the darkroom is you were in the dark, and there's nothing more ridiculous than making pictures in the dark.

I also think that if you're a practicing artist, and you're making pictures, and you're making photographs, you should make them quickly. They're not like painting. They're something you make quickly. And I think if you can't tune a picture on a computer in five minutes, you should throw it away and make another picture. And the idea that people will sit and spend a couple of hours working on a picture is unbelievably stupid to me.

Also, people who work with multiple layers, which is something that Photoshop is great at, they do manipulations in layers with an idea that you can go back and undo things, and that's an absolutely

fundamental lack of faith in yourself to make a permanent decision. And so to my mind, that's stupid, too. I think if I was compositing or collaging, I might spend more time at it. But you see, those pictures are being made by somebody who's more interested in the inside of their mind, and the way it can generate a picture, than the way the world can generate a picture, so that's a fundamental difference in

approach. I think the world is much more interesting than what I think, and that doesn't mean everybody has to feel that, but that's what I feel.

PLATON:

It is liberating. It's an incredible tool, but I'm only interested in what I want to say with it. The danger with Photoshop is it's infinite, and the worst thing I believe you

can do, when you sit down at the computer, is not know where you want to take your image. You should never sit and say, "Well, I'll dial up the contrast. No, I'll dial it down. I'll saturate it. No, I'll desaturate it." You're going to be lost very quickly. So what you have to do, before you sit down, is almost switch off the lights and ask yourself the very difficult question, what do I want to say? Can I see it in my head first? And then you sit down, and you use the tools to chase your idea, but if you don't have an idea, then the technique is dominating what you're doing.

WILKES:

There's this sense that you were almost operating in a universe as opposed to a solar system. There is no boundary, anymore, about where we can go or what you want to do. I want to share a story. When I launched the inkjet technology with Epson, I worked with Nash Editions. Mac Holbert was the printer, and he had worked with Horace Bristol, who was a wonderful *Life* magazine photographer. Horace, I believe, was in his eighties, and he sat down at a computer, and Mac was printing his work for the first time, digitally, and Mac said to him, "Hey, Horace, what do you want to do in this print?" And he says, "Well, Mac, you know that knee was always too bright. Do me a favor, just darken that down." And Mac took the wand, and went *whoosh*. And

all of a sudden, he hears this guy—he hears like crying, he's all choked up, and he turns and looks back at Horace, and he says, "Are you OK, Horace? Is everything OK?" He says, "I'm OK, Mac," he said, "but I just wish I was a younger man to take advantage of this technology." And that was the way he felt, and I believe that's the way all these guys would've felt, all the great masters—I just think, again, it was always about getting there, not how you got there.

BUSSELL:

If you go through the morgue in any newspaper, and you see how things were airbrushed, and how things were changed, and how things were printed, and cut out, I don't think you would be worried about Photoshop either.

WILKES:

This is where there's a great irony, for me, is supposedly the great masters never manipulated, or did anything. Clearly that's not the case. Guys did everything from drawing on negatives to layering negatives. I mean, photoshop was invented way before "Photoshop."

CALL THEM
SNOWFLAKES,
CALL THEM
ANYTHING YOU LIKE
WE CALL THEM

Alfred's Asterisks*

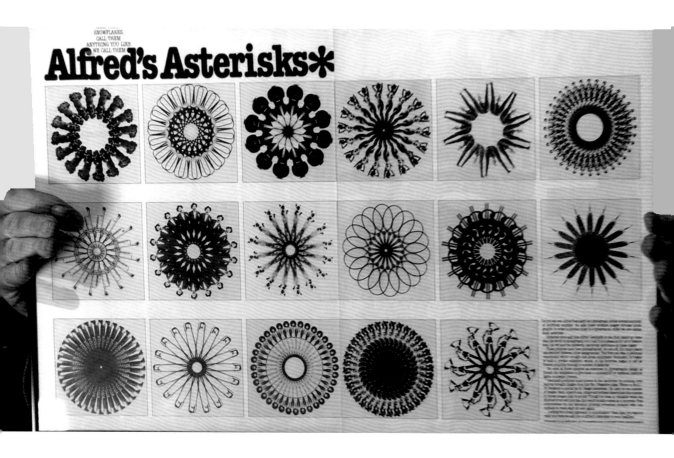

44

PHOTOSHOP BEFORE "PHOTOSHOP"

Alfred Gescheidt

I call myself a photo illustrator. And they say, "But you're a photographer." I said, "Yeah, that's why I say *photo* illustration." My first published work was in *Life* magazine, in 1951. I'm 22, I'm just a kid, and I just know, intuitively, if I'm ever going to get my career started, I've got to do something quote-unquote "different."

[*Showing his work below*] This happens to be a nude, and I did a number of them. People asked, "How'd you do that?" I said, "Well, very simple." I had a jig, which I put underneath my enlarger. I'd make one exposure, and turn the jig. Just keep turning it. Just keep turning it. Turning it. Oh, what happened if you screwed up on one? You start all over again, that's what you do! So I did a bunch of them, and they were wildly successful. I mean, a magazine called it "Alfred's Asterisks."

I remember, there was a photographer called Jerry Uelsmann, either he or his assistant, or somebody associated with him, said, "We want to know how you're doing these things. How many enlargers do you have?" And he came up to my little apartment, and he saw one D2 Omega, and said, "Well, where are the others?" I said, "That's it." I mean, they thought I had a whole battery of enlargers. In some cases, I said I did; they were someplace else. I mean, I didn't want to [*laughs*]—you know, they were so intrigued.

I met the art director of *Playboy*, and after I showed my work, he says, "I want your stuff in my magazine." I said, "Me, for *Playboy*? You're crazy." "I just want you to do what you want to do." So I had a box that said Gescheidt's World, and everything was erotic, and silly, and stupid.

So it's not computer work. It's really very simple if you think about it. But again, if you don't have the patience to start over again, you'll never be able to do it. I thought nothing of it. I don't see myself as having great patience, but in photography, I have unlimited patience, and I loved it. I mean, when that image came up, if I didn't screw it up, I was jumping up and down in the darkroom.

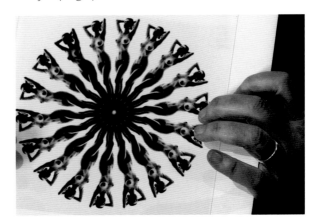

BRIDGING
THE DIVIDE

A PLATINUM PRINTER FALLS FOR INKJET

Richard Benson

I was a platinum printer for 25 years, because platinum seemed to me to always be the most beautiful way to make a matte rendition on paper of photographic tone. And I believed that, all the way through my work as an analog photographer. But the minute the inkjet printer came along, there was a more beautiful matte surface on paper for rendering tone, and I dropped platinum and became an inkjet printer. Then gradually, what's happened, the machines have gotten better and better, and the dyes or pigments have become very stable, so at this point, it seems to me that it's a more stable photographic process than we've ever had.

I have this Epson 4880 inkjet printer [pictured below]. I've taken it apart and I've built in two controls that override its registration mechanism. I can put an impression on it, and then I can roll it out and look at it, decide what I want to put on next, run it back in, and print it exactly in register.

I certainly have times where I wish the whole electronic thing would just go away, and I think the reason I'd like it to go away is that I remain enthralled with the physical object that is made without benefit of electronic technology, but as a photographer, nothing compares with what the digital media will give me. And so I have to put up with that goddamn stuff. I love an image on a piece of paper, but as I've said before, I'm an old fart, and that might be something that should go along with me. I think it's all going to be electronic display in the future.

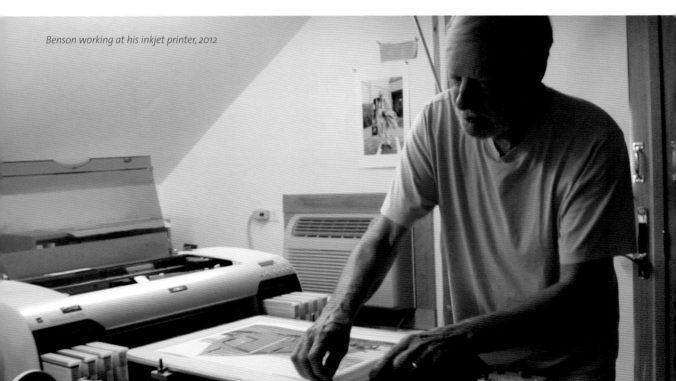

Benson working at his inkjet printer, 2012

GOING BACK TO THE DELTA

Eugene Richards

I've been a photographer for more than 40 years, having started to more seriously make pictures in the late '60s in a class that I took with the great teacher and photographer Minor White. Then in 1969 I went south to the Arkansas Delta as a VISTA volunteer, a kind of social worker. This was a year after Dr. Martin Luther King Jr. was killed, and the Delta was an impoverished place, a racially troubled, sometimes violent place. I would stay for close to four years. After being forced to leave VISTA, I helped start a community service organization and community newspaper with other ex-volunteers, and began working as a reporter/photographer.

When our organization was forced to close its doors in 1972, I returned to Dorchester, Massachusetts, my birthplace. I was fortunate then to have my work on Arkansas published in book form in 1973, though this didn't really change my life a whole lot. It was a struggle. With the exception of a few part-time teaching jobs, I seldom found work as a photographer, but I began to photograph the streets and people of my neighborhood. Some time later I borrowed the money from friends to publish the paperback volume I titled *Dorchester Days*. And despite the mostly ignored, repulsive-to-some-locals nature of the book,

it's what got my career started. I was invited to join the photographic agency Magnum and began to work occasionally for magazines, all the while increasingly aware that my work was deemed not the right stuff for galleries or collectors. My personal focus had to be books.

Racing ahead, it was in 2010 that I received a rare assignment from *National Geographic* magazine to return to the Arkansas Delta. For something like five weeks, I traveled up and down the back roads, curious to see if anything remained from my time there 40 years ago. Then, returning home, I found myself sifting through my old Arkansas contact sheets, looking at the black-and-white pictures made all those years ago. And what I uncovered were deeply personal pictures that I never really saw or never printed before, perhaps because they were not suitable for our newspaper. These pictures were from negatives that I had processed myself in a tiny clothes closet in the Delta, so they are worn and dusty to this day. The most revealing pictures are of the sharecropper families that I'd met during my time there. So even now, what I remember of my return to the Delta in 2010 is the feeling that in that place the past and the present often overlapped, became

indistinguishable one from another. I would hear voices, imagine that I saw people that I knew 40 years ago working out in the fields. And out of this confusion of time and place grew the desire to do a book.

It should be said that the pictures I made in 2010 are not black-and-white, as is so much of my work, but color. What's less important, I feel, is that these are digital pictures. Digital just being the tool at hand, digital pictures were what the magazine wanted. The Delta, it turned out, was, at least for me, a difficult place to photograph, with few people on the streets. And then the people that I met were often suspicious and shy. Still, field workers invited me to follow after them as they labored; a tough, no-nonsense motel housekeeper befriended me; and children, for whatever reason, trusted me to follow after them down a country road as they walked home. And being able to enter into people's lives is to me the magic of being a photographer.

Now, there is one photograph in the new book that I'm working on, *Red Ball of a Sun Slipping Down*, that might appear to be rather singular in nature. It's of a pair of red shoes covered with sequins that I found sitting out on the porch of an abandoned house in Lehi, Arkansas. The shoes were beautiful, incongruous to the landscape, almost magical in themselves. Dorothy's

ruby slippers from *The Wizard of Oz*. But how did they come to be there? When I returned there a month later, the shoes were gone. I searched through the row of shacks and found a door where a child had stenciled her name—Mary; the stenciled lettering was the same red as the shoes. Then on one of the walls I found the outline of where the Lucite box containing the shoes must have hung. The shack, in all probability, had been home to migrant farmworkers, the shoes a gift for little Mary.

As for the picture of the ruby slippers itself, it was made in the bright sun on a digital camera with a low ISO. In time, I went on to make a 50-inch print of it that's as sharp as a tack and strangely grain-free, more cinema in appearance than still image. It's the first digital photograph that I've made that I might say was like a crossing over, a departure from film.

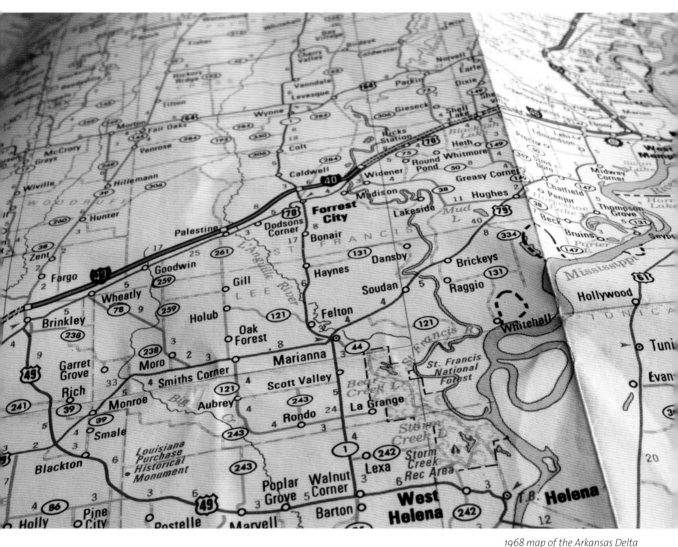

1968 map of the Arkansas Delta

TWO CENTURIES OF TECHNOLOGY

Sally Mann

An ambrotype [wet-plate process] is either a negative [on clear glass], or a positive that's made on black glass or enameled aluminum, so I do all of those things. The wet-plate negatives can be enlarged just like any other 8x10 negative, but you have to have an 8x10 enlarger, obviously. I have a 1911 Eastman Kodak enlarger. One of the curses of photography is, of course, that you can make multiples. For years, I was a slave to my multiples. Probably 20 years of my life I've spent in the darkroom making multiples. [Wet-plate positives] have been so liberating. I just make one of these things, and that's it. I'm liking that.

You can go to all kinds of extremes in getting a perfect wet-plate collodion negative. I don't go to those extremes. I do clean the glass, but not excessively, and then I pour on the collodion mixture, which is gun cotton dissolved in ether, I think. Anyway, after the pour it's submerged in silver nitrate, and then put in a specially designed wet-plate collodion holder. There's just a couple of minutes before it dries. That's why it's called wet plate; it has to be wet for the exposure.

So you take a picture, and you take it back into the darkroom to be developed. It has to be fairly dark—you can do it under a red safe light—and you pour the developer on, and then you have it right there; the image appears as you roll the developer around on the plate. Oxymoronically, collodion is sort of toilsome, tedious instant gratification, because you work really hard and you do all this work, but then you see your negative right away, so it's not dissimilar to digital in that sense.

I'm working a lot with digital now, and I have no beef with digital. I think it's great; it's been really helpful. Back in 1969, I started with a Leica. And now I have almost exactly the same Leica that I started with, only it's digital. I have a 1927 lens on it. So I am starting to do some serious work with that Leica, and it's really fun. It's also treacherous, because you take so many pictures, and then you're stuck behind the computer for weeks. Plus, there's something so seductive about the physicality of the silver print, and the sheen of the silver, and the way the darks and lights come up in the darkroom, and how you can manipulate them. There's nothing like it.

A while back I broke a plate in this bizarre accident; I've rarely broken a plate. And it was my favorite picture. In fact, we heard it break, my intern Caitlin and I heard it break, and I said, "Oh please, don't let it be the one of the man lying on the bench." And we went through them one by one, looking for the one that was broken, and of course it was the man lying on the bench.

And she, being a bright young 22-year-old, said, "No problem, we can scan it, and I'll stitch it back together." Ah!

She did, she stitched that thing back together again. So then I had a scan, except that, you know, I was going to make 30x40 gelatin silver prints of these. Then we discovered someone who is now making the actual silver Tri-X 8x10 negatives from a scan. Amazing, right? So actually, it's become an even slipperier slope. Because now, I look at all of these glass plates and say, "Oh, wouldn't they be better if I took out this spot, or increased this flaw?" or something. I now occasionally scan my wet-plate collodion negatives, rework them in Photoshop, and then have them made back into gelatin silver negatives. Now, talk about a leap. I mean, you're talking a century and a half, two centuries really, of technology bouncing back and forth.

I don't think there's unlimited artistic potential with digital. I think these young kids coming out of photography schools are looking for authenticity and something different. They're going to look back. They go to a museum and see a gorgeous Robert Frank, and they go, wow, I can't do that, I wonder how I could do that. And, of course, they can't, because they don't make paper like that anymore. But they can come close with an old-fashioned silver print. And they want to do that; they know it's beautiful. That's inarguable. Or they'll see something that's unique, one of a kind, and could not possibly have been made in digital, like the work by that man [Miroslav Tichý] who photographed with a homemade telephoto. And they're going to hunger for that.

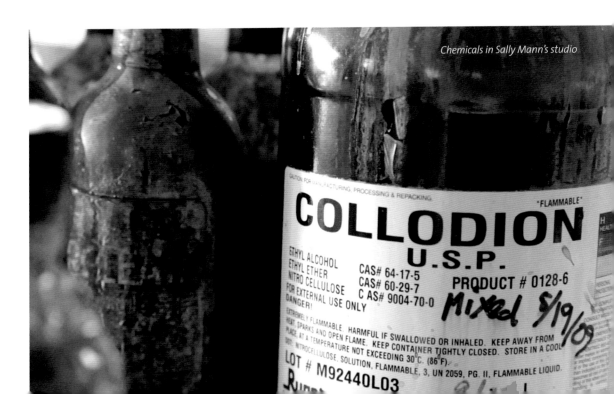

Chemicals in Sally Mann's studio

PERSPECTIVES ON THE DIGITAL (R)EVOLUTION

TAKESHI AKAGI
OWNER, NIPPON PHOTOCLINIC

Interviewed December 5, 2008, at Nippon Photoclinic in New York City

I was working for a Japanese camera manufacturer and got assigned to the United States, and later on I quit and started my own business here. We moved here in 1984 and started this Nippon Clinic. Photographers got to know us little by little, and they trust us for quality, and we've been doing very good work. From that time on, we have done maintenance for professional people.

To tell you the truth, I don't have much knowledge about the digital camera. You like it or not, all photo equipment will go to the digital camera, so the new generation will have to learn the digital camera.

I've been seeing our clients, the older generation, the older photographers, they don't like the digital camera, sure. And it means more workload for editing, stuff like that, and so they don't like it. But the young generation, young photographers, they like it. They love it, love to deal with digital cameras because they've grown up with the computer.

My clients are not just older photographers. The young photographers are my clients, too. And some in the young generation are curious about the analog camera. The younger generation somehow, for some reason, is very interested in shooting with those analog cameras. For example, the half-frame camera. They are very popular in this market right now.

It's interesting, when I meet younger photographers they don't understand, like 15th, 30th, 60th, doesn't mean anything to them. They don't know, because with the digital you get every step in between. They don't know what a shutter sounds like. They don't care—they just use the camera as a tool, a utility tool. They gravitate toward computer things, I believe. But the older generation likes the sound of a shutter release, the sound of winding, and that sort of thing.

I think [servicing analog cameras], as a business, will not be good in the future, but it will keep going, I believe. Many, many in the world...many cameras were made, and people used to shoot with film, and some people have a very strong nostalgia for the analog camera, so I think we'll still keep going.

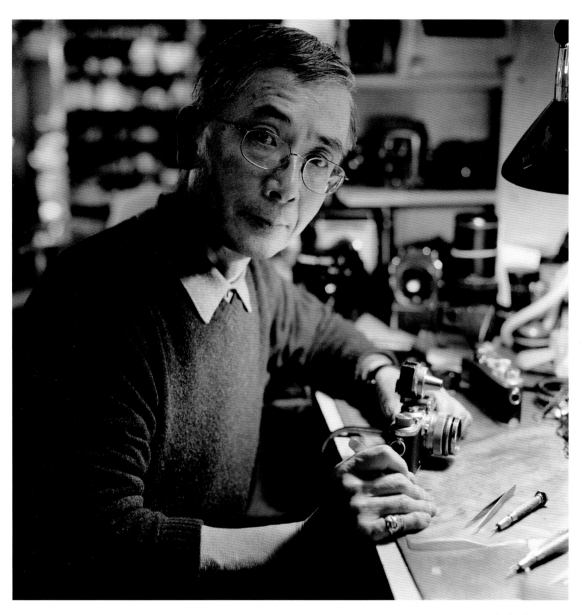

Takeshi Akagi, 2008

ADAM BARTOS

PHOTOGRAPHER

Interviewed January 18, 2011, at his studio in New York City

Starting out I had a bias against beautiful and laborious printmaking, and I felt that creating the image was more relevant than making the print. What mattered the most to me was the idea of being in the right place at the right moment and seeing, not making a print. Over time I've grown to see that is not a satisfying distinction to make, and I love looking at prints. I feel that the image and the object together are one thing.

The view camera demands a way of working that I enjoy. I like the process of using it—though I do think about this: If I could take a picture with my Leica that looked exactly the same as the one I'm taking with my 5x7, why would I bother? But even if that were technically possible, the way of working with a view camera is completely different. The weight of it, the business and theater of setting it up,

and finally, the quality of time it injects into the image itself, are unique. I love the moment when I can closely observe the ground glass and tinker with the frame, and all of this affects the final result. The camera as a tool matters a lot, whether it's digital or not.

The choices photographing these days are harder to make than ever. The sense of insignificance, the questioning that comes up. Images are absolutely everywhere. Exploring the world used to be such a big part of what I did as a photographer. Now, everyone can see a street corner in say, Lima, Peru, on Google Earth. You know precisely where it is, and you could decide to go exactly there and photograph if you wanted to. I suppose you just have to more deeply follow your own connection with the subject...and that's how it's always been.

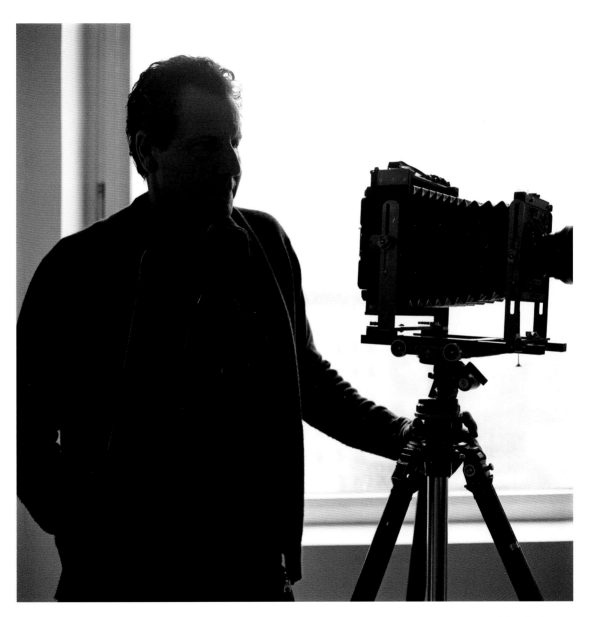

Adam Bartos, 2011

DEBORAH BELL
PHOTOGRAPHY DEALER, GALLERIST

Interviewed December 5, 2008, at Deborah Bell Gallery, New York City

I've been a dealer for 20 or 25 years. I specialize in photography, of course, and I always sort of summarize by saying that I handle the old masters of the 20th century, but I have some contemporary photographers, as well, whom I represent.

To me, the special quality about prints that are processed in the darkroom, and made from film, is the presence of silver. Silver is magical, and there's always, to my eye anyway, a certain depth in the print. The very fact that there is that baryta layer on top, and then an emulsion sitting on top of it, gives the print a certain depth to begin with, and that surface is just beautiful. The various surfaces of the papers are beautiful to me. And observing the characteristics of black-and-white prints: How cold is the tone, how warm is the tone, and what can be done with bleach, and how did the photographer manipulate the prints? It will always be fascinating to me, and it's what I come from. I can't help but love it.

I'm open to whatever the future brings with technology, because I realize now that it's like anything else, any other process. Sometimes the work is compatible with the process, and sometimes it isn't. I mean, we love William Eggleston's dye transfers so much because somehow his work is really a great match with that process. So I've often wondered also whether photographers will be willing to make the transition to digital when and if they can't get silver paper anymore, or film.

Do I think film has a future? I think the answer is very much based upon how much it can still be used in the commercial world, and that looks pretty bleak, doesn't it? I do think that it has a future, because it probably will continue to offer something that we can't get from digital.

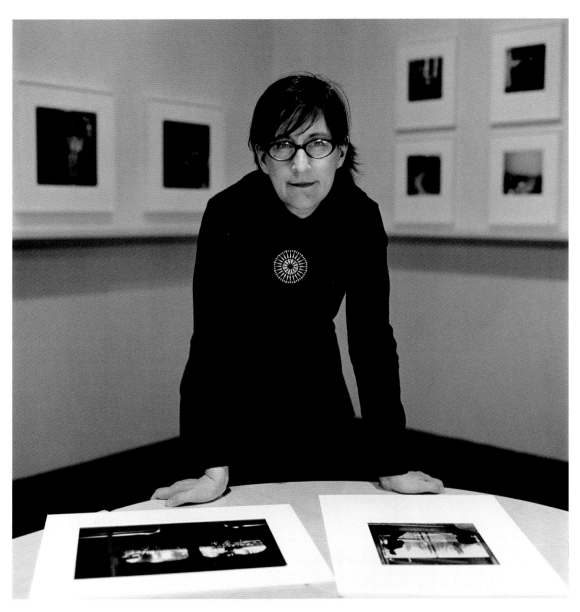

Deborah Bell, 2008

RICHARD BENSON

MASTER PRINTER, PHOTOGRAPHER, DISTINGUISHED EDUCATOR

Interviewed October 5, 2012, at his home and studio in Newport, Rhode Island

Silver is basically dead, and by God, it should be. It's overdue. It was great while we had it.

I think the digital capture is far superior on every level. We get cameras now where the ASA is at levels we never had with silver. The color rendition, to my mind, has always been better coming from digital devices than it was from film. Silver is inherently a monochromatic process. It's a black-and-white process, and we had to cobble color up. And that's not true with digital. With digital, we simply run three channels, and we can get beautiful color. The quality of the rendition is vastly superior.

The speed of the transition, I think, has been remarkable. I think it's happened for two reasons. One reason is the very rapid development of the new technology, and the other reason is the inability of the huge silver-based entities to adapt. I mean it's quite astonishing that Agfa and Kodak both fell like mammoths being shot with a gun. You know, it's unbelievable. They simply couldn't adapt to the change. But I think it's because the technology grew so rapidly, and became so good so quickly. The remarkable thing about Kodak is it was one of the great innovators...and yet

it couldn't heave its great sluggish body over to this new medium.

I think people are doing processes like collodion and platinum for reasons other than image rendition. I think they're doing them for the way the process can impose itself on the image, and I think that is the kind of content they're interested in. That's of no interest to me.

There's a character to the silver print that nothing else has. And I don't think the digital technology should be used to imitate that. I think we should embrace the door that opens and the completely different appearances that things have when printed with the new technology. I'm not for a minute saying that the silver print can be matched by the inkjet printer, but the silver print tends to be one thing, and the inkjet print can be many things.

Technology is a wave front, and you can decide to get on that wave and surf it, or you can decide to bounce up and down in the water as the waves go by. And if you get up on the wave and surf it, you're going to tumble half the time, but it's going to be an exciting ride, and you're going to go somewhere that the person doesn't go who sits

in the water in one place. The wave moves and the water doesn't, and if you stay in the water, you just bob up and down like some old thing. So it's always more interesting to me to get on that front of technology and go somewhere where we don't know where we're going. That's what I'm really interested in.

MEGHAN BOODY
PHOTOGRAPHER

Interviewed March 5, 2011, at Affirmation Arts, New York City, during her exhibition The Lighthouse Project II: Visitation

Often I'll simply say I'm a photographer. But I also make sculpture. A multimedia artist. I haven't really come up with a term that I like. Composited photography: I think that describes at least the image part, perfectly.

These days I usually shoot automatic, and autofocus. Sometimes I do miss the mechanics of taking a picture and the alchemy of the darkroom. There's nothing like that exciting moment of watching your image surface in the bath of developer, and I don't get to experience that anymore. However, I will happily trade that off for not having to be breathing in toxic chemicals. At one point I was dipping my hands into all of the solutions—I had brown fingernails for a couple years!

I've always had this desire to merge many disparate layers. As a child I spent hours cutting things out of magazines and gluing them together painstakingly, trying to get things as seamless as possible. Photoshop is perfectly suited for my particular obsession...if there wasn't Photoshop I'd probably be running myself ragged with the glue and scissors. Photoshop is a tool, like a paintbrush or a camera, whose merit depends on the vision and ability of the user. The way I use it brings me closer to painters than to photographers, in the way that I arrange my compositions and "paint" with fragments of photographs.

The medium of photography has expanded in infinite ways, to the point where it's often not clear what a photograph is anymore. But ultimately, labels and classifications don't matter. Whether you're capturing Cartier-Bresson's decisive moment or creating alternate realities with digital photography, it's more about following your vision and your heart's desire in whatever mishmash of mediums you choose.

Richard Benson, 2012

Meghan Boody, 2011

MARK BUSSELL

PHOTOGRAPHER, FORMER PICTURE EDITOR OF THE *NEW YORK TIMES* AND *NEW YORK TIMES MAGAZINE*

Interviewed March 17, 2011, at his home in New York City

In the '90s, this transition began from black and white to color, then to digital, and I sort of watched it happen. I helped here and there. In fact I, myself, being an image maker, was interested in exploring the earliest versions of doing these things. I remember the first machine that actually processed digital images. I think it was made by a company called Scitex, and I had to go up to New Hampshire to look at it. And the machine was about the size of this room, and what you do is you put a negative in it, and then it comes out digitized at the other end, and the thing I think cost a half a million dollars. It's pretty much what you can buy now, you know, for 10 or 15 dollars.

Most of the older photographers [at the *New York Times*], a lot of them still—they didn't use their Speed Graphics, but they talked about them every day, and some of them were still in their lockers. A lot of the older people loved their old stuff and weren't even imagining ever making a change. But then some of those made a change to Leicas before we got there. I hired a bunch of people because the *Times* expanded, so I hired younger people who were already shooting color

for the most part on their own, for one reason or another. Also, negative film suddenly got better, and there was a big effort to make color negative film better, and it never looked like Kodachrome, but you began to see it in newspapers. And I remember when *Time* and *Newsweek* were black-and-white and went to color, too. So this was going on, and most of the younger people just had a greater interest in color, and the older—I was going to say guys because they're all guys—the older guys didn't. But to me, that's sort of the gumbo of life. I liked the fact that there were people who were in love with what they were doing. It didn't matter; they didn't have to love everything.

There's a tendency to love what you know and not to want to give it up, especially when new things happen. But, you know, people probably felt that way about their horses when trains and cars were invented. And so, while I wasn't dying to let go of Kodachrome or black and white, I also realized that digital had some potential. This had the potential for moving images quickly, for changing them, for distributing them in ways that didn't exist before. And while I had no idea of where it

Mark Bussell, 2011

might go or end up, I found it intriguing. Then when it became clear that websites were going to be a place to see photographs—no idea how big they would be or how influential they would be, but they would be part of this dominion of how we see pictures—suddenly it sparked to me that video is very important, that sound is very important, that we're not going to be able to deliver things in the simple way that we had in the past.

I think that the change from chemical to digital mostly affects the delivery of pictures—how we see them, where we see them. Two years ago, during the protest in Iran, we were able to see so quickly the cell phone picture of the woman who was killed. It's not a photograph that we'd see at the Museum of Modern Art up on the wall with a frame, but it's an incredibly important image. And it's not in competition with the beautiful black-and-white print that someone's making by hand. They're just two different things.

I think of them as different dialects of the same language. It's a great language, and there are many dialects in photography.

As a kid I had an acoustic guitar. Got a little older, got an electric guitar. It didn't mean that the acoustic guitar that I had, or any great acoustic guitar playing that I ever heard, was less meaningful. In fact, it's enhanced by the fact that there's even more that you could judge and compare it to. So I think black and white to color is acoustic to electric.

I started in art and ended up accidentally in journalism, where I don't feel I am anymore. I'm not back to where I was, but in the next phase of where one could be if you're dealing with images made by cameras. And I just don't see these walls or barriers. I don't see the debate. I understand the discussion, but I don't see where one takes away from the other. I think black and white, color, and digital all add to each other, actually.

JOHN COHEN

PHOTOGRAPHER, FILMMAKER, MUSICIAN, MUSICOLOGIST, DISTINGUISHED EDUCATOR

Interviewed November 18, 2008, at his home in Putnam County, New York

When I was in art school, I had been studying painting and got caught up in photography. It got me out of painting, out of the studio, into the real world. And here I am. It became an opening up of the world. Early on I photographed in Morocco and Peru, the most exotic places in the world. And then I photographed in the art world and the Beat generation, because they were around where I lived in New York City. It wasn't like an assignment. Then I went to Kentucky because music took me there. I'd started the New Lost City Ramblers. We were doing songs of the Depression, so I searched for old music and photographed at the same time. One thing led to another: The things I was interested in, music, culture, other people's lives became the main subject; they were things not at all like where I grew up. Later my family became a subject.

Now the problem is, over such a long period of time, none of my interests have gone away. So either I build on what I've already done or I build on what I didn't do. It's not like looking for new assignments. I never did very well with assignments from the magazines. I realized that very

early. So then I had to just pursue what was most interesting to me. Music took over for a while, and I photographed a lot of music. And then I made films. And they were about music. I also made films about weaving. All my interests are still with me...nothing's gone away.

I remember *Life* magazine used to be the main source of communication before television got big. And a lot of people aspired, and thought it was the pinnacle of success, to have a picture in *Life* magazine. What was really odd about *Life* magazine was, we'd all run to see every week who got the credit, PHOTOGRAPH BY SO-AND-SO—all the young freelancers and the old-timers, whatever it was. But you think about it. You took the picture. They took the film from you. One guy there developed it. Another guy contact printed it. Some editor looked at the contact prints and said, "Print this one." Somebody else printed it. Somebody else laid out the design. Somebody else wrote the captions, and it came out PHOTOGRAPH BY JOHN COHEN, let's say. And they kept the film anyhow. I mean, what the hell is that? What kind of a system is that? And you needed a lot of strength

John Cohen, 2008

to get past that system. There weren't galleries in those days.

When I started, there was only one gallery in all of America that showed photography. It was called Limelight Gallery. And I had a show there. I was very lucky in my early Peru work. But now there's, you know, galleries all over the place. And there's AIPAD [Association of International Photography Art Dealers], these big gatherings of photography dealers, international dealers, collectors, and things. And that's a very different world.

People look at so many more images now. When I was a kid, images were sort of precious and magical. Now people grow up with photography all around them, images everywhere. Probably they have more of a struggle to know what's good, or to even find out what's personal in their own work.

I'm not really a good one to talk about digital and its effect. I saw it happening. And I think...my pot was so full already

that I said, OK I won't go down the digital road. In a way, I'm going to be a dinosaur. I don't expect my own kids or students to do what I did. But I'm going to continue doing what I did. You can make the easy argument that digital and video are the art of today, and I belong in the Museum of Natural History with the dinosaurs. And I don't mind that. I sort of accept that.

When I see something that's exciting to me—that's a good situation. It's the excitement that counts, not whether it's digital or analog. Of course, I'm talking from a weird perspective. One of the recordings that I made in Peru, of a little Peruvian girl singing a song unaccompanied, was put onto a gold-plated phonograph mounted onto the side of the Voyager spacecraft. It's going to be out there for a while. It's outside of the solar system. I don't know who's going to listen to it, if they're going to like it or not. But, you know, you get into these weird, odd moments that make the whole discussion about photographic media seem stupid. But we live in the stupid world and not out in outer space.

GREGORY CREWDSON

PHOTOGRAPHER, DISTINGUISHED EDUCATOR

Interviewed December 4, 2009, at his studio in New York City

There's something lost and something gained, always, in any advancement. There's always a positive and a negative, no pun intended. I knew for me it was just having to change my mind-set and challenge myself, because I think that's what all artists do, or have to do, particularly when you produce a body of work that becomes recognizably yours. You have to at certain points challenge it. You have to undermine it. You have to unsettle it. And one way of doing that is to change the camera, in a certain sense, because it shakes things up, and you learn new things in doing so. [After using an 8x10 film camera for many years, Crewdson shot *Sanctuary* with a digital Phase One.]

My pictures are really about trying to use light to tell a story. So the 8x10 was always such a great vessel for that, like a container for that. But it was a really arduous process. When I shot the *Beneath the Roses* pictures, we established a frame, and then if we were shooting on location, we'd shoot 50, 60 plates, 8x10 plates, over the course of two hours. And then all those pictures had to be developed, and we made contact prints. Then I would go over each contact print and edit it all down to four or five different negatives to be scanned, and those

images would be composited. So months and months of work.

We knew that we'd have to shoot every imaginable focus, so we'd have it later on if we needed it. So that was a fairly slow process, and it just came out of necessity, because I wanted my pictures to have absolute resolution. I want a complete transparency. I want everything to be in focus. I don't want the viewer to be aware of anything photographic, if that makes sense. So nothing that's out of focus or blurred, no grain, no pixels. I want a complete purity. And that became possible by using the composites.

My most recent body of pictures, which I just finished production on [*Sanctuary*, Harry N. Abrams, 2010], which is going to be shown next year, is a dramatic departure: digital camera, black and white.

Before I did these new pictures though, I did rigorous tests. We shot the same subject with both cameras; we were in Massachusetts, and we shot landscape pictures with the 8x10 camera and with the digital camera. Same frame. And we'd make comparison tests. And there was no comparison between them. The

Gregory Crewdson, 2009

digital camera was sharper. The prints were sharper. Obviously, much more depth of field. And because there's no scan, there wasn't a layer of remove, you know. So I don't know if I'll go back to shooting film. I just don't know if I will.

There are certain artists you can't imagine not using film. And I was one of them, actually. I really thought that I would never give up shooting the 8x10 film. So you know, who knows what happens after this?

I feel like my pictures are always grounded in realism. In the end, I consider myself a realist photographer. And so when I'm using digital technology, it's not with special effects in mind. It's really to try to re-create what I saw in front of me, in terms of focus and depth of field and clarity. It's not trying to create something fantastical at all.

But my general thought about all of this is the camera's just a tool that gets you there. I don't have any—there's no ideology or dogma. To me, what's most important is the artist's imagination or the artist's story, you know, the story that needs to come out. And by any means necessary, the final picture just needs to reflect the worldview of the artist.

JOHN CYR
PHOTOGRAPHER, MASTER PRINTER

Interviewed May 7, 2012, in his darkroom in Brooklyn, New York

My work as a black-and-white printer led me to the project that I've been working on for the past two years [*Developer Trays*, powerHouse Books, 2014]. I've been photographing the developer trays of photographers who have a strong history in analog black-and-white printing.

The tray bears the traces of all the work that each photographer has produced. The trays are often plastic, or stainless steel, and they take on a certain texture and color that's unique after many years of use. The tray becomes a photographic fingerprint of a lifetime of work. The chemical process has created this object, and transformed it from something that is sterile, and right off the shelf, to something that has been truly lived in and worked in. I think they're important artifacts.

I truly believe that if I had waited another 10 years, I could probably only have shot 50 trays out of the 82 that I had done. Maybe even less. Who knows? I was not able to get some trays because they had already been thrown away, but it was still enough to create an archive of this process that has been used almost more than any other process.

John Cyr, 2012

RUUD VAN EMPEL

PHOTOGRAPHER

Interviewed June 2, 2010, at his studio in Amsterdam, The Netherlands

I started out with collage at first. The photocopy machine developed in the 1980s, and you could actually enlarge a little bit and that sort of thing. That was quite interesting already for me. So I was on my bicycle going to the photocopy shop all the time, all day long and making another copy and trying it at home. And then it's not big enough, again, and going back and forth.

I was very happy when the computer came, and Photoshop came. I had so many ideas coming up of what I could do, suddenly. I manipulate everything. I create everything out of photos that I take. So it's really in between painting and photography in a way. I think it is, in the end, photography, because photography has gone very wide. There are many possibilities nowadays.

Before digital, I shot on slides, large slides, with my Mamiya camera. It was a lot of work, of course, because if I have a model, I could shoot about 10 to 20 pictures. Then I have to bring it to the lab and then wait for a week, and then it comes back. Then I have to scan everything. And it has a grain in it also, which is not really sharp. Now I use digital, and digital is very sharp.

And I remember that the grain gave me some problems sometimes with the montage also. Because if I enlarge something, the grain becomes bigger. Or when I make it smaller, it becomes suddenly more sharp. I had a lot of sharpness problems with film. So I was happy to work digital. That had problems, also, in the beginning, because the resolution wasn't very high. But with the good cameras right now, I have no problem at all.

Everything is so sharp, and I can work so fast. That creates a lot of possibilities for me. I mean, if you like painting, of course, if you have an idea, you start working immediately. That's also possible now with photography. I can take a photo and immediately do something with it, put it in the computer and work with it.

My snapshots from holidays, those sorts of things, I don't print anymore, because I don't have time for that. And I would like to print them. I know it's important to print them, because we don't know if they will disappear. The videos that I took in 1980, they are disappearing. Maybe there will be a new system in 20 years, a completely new system, that cannot read this system, for instance, and all my information

will be gone. It could be like that. That's a reality in this kind of work, I think, in photography. Photography vanishes after a while, after a long while. I work with Cibachrome, which is a long-lasting print technique that has proven itself already. It's over 50 years old. And prints 50 years old are still very good today. So that is a good thing. But that's just 50 years, eh? It's not a very long time actually.

As an artist, I think it would be strange to work in an old technique. I mean, I don't mind if people do that, but I want to do something which is about today or my days, my time and age. I don't work with film, and I haven't for a long time. I won't miss it, not at all. But I'm afraid of the disappearance of Cibachrome all the time. I like Cibachrome. For me, it's perfect.

Ilfochrome (the dye-destruction process originally known as Cibachrome) was discontinued in 2011.

ELLIOTT ERWITT
PHOTOGRAPHER

Interviewed June 11, 2009, at his studio in New York City

Does it matter whether I shoot digital or film? Yes, of course, it matters. Right now, I'm more comfortable shooting, as I always have been, my own personal work with my little camera. Professionally, I'm delighted to shoot with digital, because you're out of it very quickly, it's in and out, it's pretty foolproof. You get a result that you can see right away, and it's quite efficient. And it's also color, which is something that I don't normally do for myself.

Film is a lot more trouble, so you think twice before you press the button, or before you make a print. Digital, you don't have to think, you can just shoot away,

like with a machine gun. And people do that, I've seen that. I just received some pictures of my grandson who graduated from high school, and his father took the pictures. There are 50 pictures that all look the same, and they're all bad. And if he'd taken maybe two or three, they probably would've been a lot better. I mean, he's not a professional photographer... but here, it's the machine-gun approach; eventually, you'll hit something.

You know, skills in photography are not so complicated. I mean, it's not brain surgery. It's pretty simple stuff. I don't put much on the technical thing. Whereas, on the digital, I suppose you have to know

Ruud van Empel, 2010

Elliott Erwitt, 2009

computers, you have to know something that I don't know, and that I'm not interested in knowing. So, in that sense, for me, that would be more complicated. But more complicated simply because I don't have any interest in it.

A good black-and-white print from a good negative is a very satisfying object, if the picture is good. If the picture is not good, it's just a piece of paper. Yeah, a good print is special. No question.

If somebody shows me a good picture, I don't say, what kind of film did you use, or what camera did you use; it's an irrelevant question.

The result is the only thing that counts; how you get to it is immaterial.

JASON ESKENAZI
PHOTOGRAPHER

Interviewed March 17, 2011, at his home in Brooklyn, New York

I have a project called *Double Zero*. When I was shooting film, years and years ago, I just noticed that the first half of the frame was very beautiful, and I saved them, and I just threw them in a box. I said, "OK, one day I want to do something with those half frames." It seemed like the roll, which you don't get in digital anymore, was being born—was becoming, somehow. Always, when you're shooting film, we all know that your best frames are happening at 35 and 36, and you might get a 37th frame out of that, and then that's it, you have to wind up the film and roll it in, and as you're putting the new roll in, you're still shooting while you're loading. And so, the *Double Zero* project came out of that. These are unconscious frames without looking in the viewfinder.

I have a box full of negatives of these things. I don't know how many hundreds—probably not more than a few hundred of them. Now I'm just trying to think what format the project is going to have. It'll be about photography. It'll be about that loss of film, and the physicality of what film brings that digital photography doesn't.

I like the process from beginning to end. I think, you know, it's a way of life. You walk around, you snap pictures, you work on projects, you take the film home, you develop it, you make the contact sheets, you live with those contact

Jason Eskenazi, 2011

sheets, you grease-pencil them, you think about it; then eventually you go into the darkroom and you see the first prints come up. So I think it's the process that is really important, to sort of see the whole thing through.

Even though I'm rooted in the black-and-white tradition, and I love it and that's the way I express myself, I do embrace all other formats, ways to shoot things. Even digital, it's fine...just a new way to look at things.

ALFRED GESCHEIDT (1926–2012)
PHOTOGRAPHER

Interviewed February 3, 2011, at his home in New York City

When I was going to buy a computer, there was an ad—I went to someplace in the wilds of Brooklyn. And the guy was upgrading his computer, and I said, "What do you do?" He said, "Oh, I'm a designer." So he showed me some of the pictures that he designed using a computer. And I said, "Well, you might be a great designer, and you know how to use a computer, but I don't like the designs." You don't tell that to somebody. I didn't buy his computer, but that's my answer to you. You still have to have an idea. And you have to be able to execute it. A computer would certainly make a lot of this much easier. Yeah. But I don't feel in a way that I missed anything.

I did what I had to do the long way, the short way, the complicated way, the throw-out way, whatever way it was. I just stayed with it, and so it doesn't bother me. I mean, if I was 25 years old and was in the field, I'd certainly have a computer. That's the way it goes. But the idea is king, however you do it.

I would never walk in a room and say [of myself], "Here's a guy that doesn't use computers, he doesn't even know what Photoshop is." Let them say that. And they say, "Hey, how'd you do that without Photoshop?" Well, I did it the hard way. Man Ray didn't have computers.

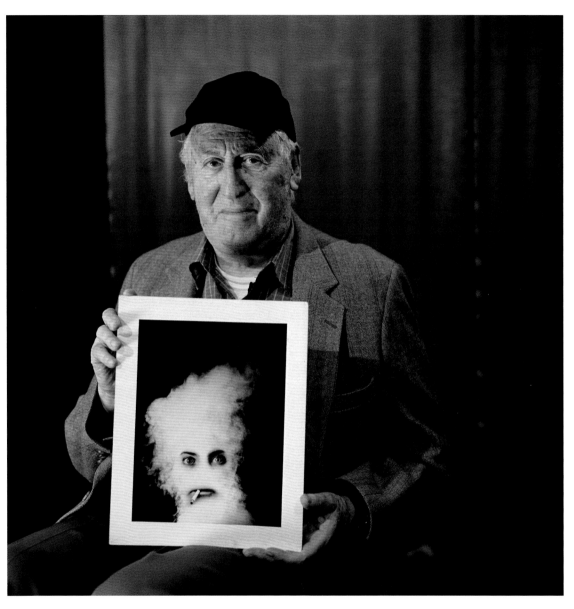

Alfred Gescheidt, 2011

David Goldblatt, 2009

DAVID GOLDBLATT
PHOTOGRAPHER

Interviewed July 18, 2009, at the New Museum, New York City, during his exhibition Intersections Intersected: The Photography of David Goldblatt

I was born in Randfontein, South Africa, in 1930. I started taking pictures when I was at high school, probably in about 1947, and became obsessed with it probably from about 1949, 1950. I've been a professional photographer since the 15th of September 1963, when I sold the family business and handed over the keys to the men who'd bought it on that day. The personal work over the years has all been engaged with the society in which I live: South Africa.

Whether it was personal work or professional work, I used whatever camera was appropriate for the job. For more than 20 years my main camera has been a 4x5 view camera. In between I have acquired a digital Hasselblad. I haven't bonded with it. I don't feel really strongly attached to it, but for certain work it's ideal. This Hasselblad camera will do your washing, it will iron your clothes, it will do everything you want, but all I want is a basic camera to get on with the job. A basic camera suits me very well.

Over the years, I've used color transparency and color negative materials, and I've used black-and-white negative materials, and from printing my own work I've learned the value of a fully exposed negative. If there's one abomination in the sight of God in photography, it's an underexposed negative. But with a fully exposed negative, you have the raw material for doing a great deal.

During the years of apartheid, I used black-and-white film virtually exclusively, for my personal work. Partly this was because I found color too sweet to express the things that I wanted to express, and partly because I found color was such a limited medium. The transparency material—either you hit it right or you hit it wrong. There was almost no possibility of working on the image. I'm not a technician and I can't put a quality to this, but as far as I've been able to determine in the little experience that I've had of them, the digital image doesn't have the same extended tonal range as film does, or the potential that it has in film. So I use film because it is most suited to what I want to do.

I printed all of my own black-and-white work. If I was engaged on a personal project, perhaps producing a book and making

the prints for reproduction, I would work 10, 12, 14 hours a day in the darkroom. I mostly made 12x16s, which is not a size that you Americans are familiar with, but that was a comfortable compromise. Occasionally I made 16x20s, and more occasionally 20x24s. There used to be a marvelous German paper called Tura that was extraordinarily rich, and when I see one of my prints in that I immediately know what it is; it's just very rewarding.

When I make fine prints today, they're fiber-based gelatin silver prints. We have a laboratory in Cape Town that is capable of taking my computer files, which are digital, obviously, and printing those on fiber-based gelatin silver paper,

chemically processed. And the prints that are coming out of that process are excellent, as good as or better than anything I've made. It has also liberated me, because I can now spend more time taking pictures and less time in the darkroom trying to make prints that I'm satisfied with.

I don't consider the inkjet black-and-white prints suitable for ultimate use. I don't think they have that kind of quality—or archival quality. To me, there is still a difference in a well-made silver print from a well-made inkjet print in black and white. There is something about the depth of the image. It's very subtle but, for me, important.

KEN HACKMAN

PHOTOGRAPHER, FORMER CHIEF OF PHOTOJOURNALISM, US AIR FORCE, AND VISUAL INFORMATION CONSULTANT, US DEPARTMENT OF DEFENSE

Interviewed June 9, 2012, in Hanover, Maryland

When I started photography, that was the old days of the Speed Graphic. And we moved from that to two-and-a-quarter Rolleis, and then to 35 millimeter and Kodachrome film, which I loved, and everyone else did also. And then, in the late '80s I guess, came digital. We called it digital; it was really Sony analog cameras. Still-video cameras, if you will. We got involved with those, and we used them when covering the invasion down in Panama for Operation Just Cause during George H.W. Bush's administration. The reason the military loved that camera was because of the immediacy. We used to think we were really great if we shot something in Vietnam and we had it back in the States and ready to look at in a week. With Sony Mavicas and being able to transmit, we could do it in not days, not even hours—less than an hour.

Sony Mavica, for the time, was fine. We didn't have anything better, and we still shot a lot of film. Then we started the transition with Eastman Kodak. We kind of got in bed with Eastman Kodak and became a beta test site for them,

checking not only their cameras and their CCDs, but then Eastman got in bed with Nikon and made the DCS 100, which was a digital camera attachment for a Nikon F3 body. The hard drive was about the size of a briefcase—about 12 inches square, and about three, four inches deep, that you carried over your shoulder. It wasn't very mobile, and you had to wait while the hard disk literally spun up. Fortunately, that didn't last too long, although we ended up having a couple of those cameras.

As we progressed in the '90s, it became evident to the military that they really wanted to go to digital. One of the reasons I already said was the immediacy. A second reason was we had to get rid of the chemicals. They didn't like the chemicals, because then the Environmental Protection Agency came into being, and everybody was concerned about groundwater and things like that. So we transitioned rather rapidly from film into digital. The bean counters, the people who knew nothing about photography, didn't care about photography, said, "You

will get out of that, because we're not going to buy you any more processing equipment. We're not going to process your film. You are going to have to go to digital." We had to. And we did. In fact, when we did Desert Storm and Desert Shield in '91, we were making that transformation and we were using satellite uplink to send our images back. After that it just steamrolled. I'll be honest with you. I knew digital would come, and I knew it would be here soon; I just didn't realize how soon.

Kodak blew it. And it's too bad. Kodak did not pursue what they were the leaders in. Kodak is going to be a name that fits right up there with the Packard automobile. I don't feel any nostalgia for the film era. As a photographer, I much preferred creating the image. I did the things you had to do after that, as far as processing and printing and all that, but I never loved that. I love the film era; I'm glad I was there, but I don't want to go back.

It's almost too easy to make an image today, and some people don't really do their homework and know that a good picture in digital isn't different from a good picture in film. You still have to be aware of lighting, contrast, where you're focusing, depth of field—all those things carry forward to digital; we didn't lose those. But I'm afraid that some of the younger photographers, because it's so easy, won't learn that, and that's too bad. You have to teach them and let them appreciate that sometimes the best thing to do is just stop, and look, and see, and say to yourself, what am I trying to say? Because too many people pick up a camera and press that button without thinking. Those same people would never sit at a typewriter or a computer and start typing without thinking, because they would type gibberish. Well, too many people are making visual gibberish. So put the brain in motion before the hand starts hitting that shutter button.

Ken Hackman, 2012

CHARLES HARBUTT
PHOTOGRAPHER, DISTINGUISHED EDUCATOR

Interviewed May 20, 2010, at his home in New York City

I think it's part of the American tradition that photographers make their own prints. It's not the Magnum tradition at all. Very few of the European photographers make their own prints. In part, because Magnum would pay for it. They had a distribution system, a physical distribution system. Now it's all digital. I made prints for exhibits and for the book [*Travelog*, MIT Press, 1974] because I felt I made better prints than commercial labs did. In fact, in the process of making the prints and staring at them, I often discovered what they were about.

You know, I think the biggest problem is this very American attitude—we're stuck in this discussion of the moment about digital versus analog because we mistake technique for form. I don't believe that. I don't believe Ansel Adams's F/64 school was a form; that was just a technique. And I don't believe "digital versus analog"—I don't believe that you're discussing two forms. There are implications, formal implications, but the problem for photographers still is very simple: What do you point the camera at, where do you stand to point it, when do you shoot? How do you record and deliver the image? That's not changed so much as expanded. So I think that's such an American attitude, that technique changes everything. We still can make prints—something with a physical existence that can be seen and held. It's not just glimpsed on the computer screen or posted as a selfie on Facebook.

Students are far superior to me in their ability to work with Photoshop. But what they're doing with Photoshop is really—some of them aren't—but many are so used to the perfect image from advertising that they shoot what to my mind is a dull photograph, something that illustrates some concept or theory. They then spend weeks and weeks spotting it, getting the colors right, blowing it up to mural size. And you look at it and you think, you did all of that? Why? What's the point? I remember the delight I had when looking at Robert Frank's retrospective book and discovering a lovely picture of Mary Frank and Pablo with a huge unspotted hair. Yes, I thought, that's what photographs look like in their natural state. A very liberating idea. Who cares about perfection? The world's not perfect, so a perfect picture is a lie.

We gave the scholarship for the best photography in the school [Parsons, where Harbutt currently teaches] to a student who was shooting with a phone. And the thing was, she always had the phone with her. She was a photographer 24/7, out there interacting with the world, and it cost her nothing. I think that's spectacular.

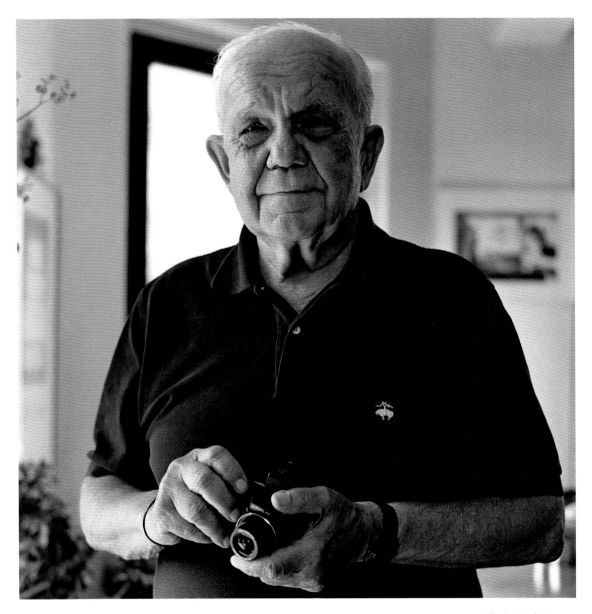

Charles Harbutt, 2010

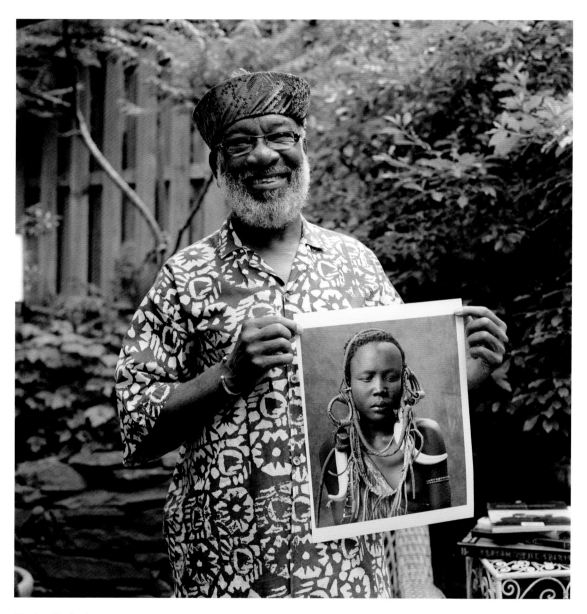

Chester Higgins Jr., 2012

CHESTER HIGGINS JR.
PHOTOGRAPHER

Interviewed May 23, 2012, at his home in Brooklyn, New York

I've been a staff photographer for the *New York Times* since 1975. My personal work has been one of using the camera to discover and explore the many various aspects of my community, the African-American community, and also, the African continental community.

I was never a darkroom guy. I have one printer I work with for the platinum prints, and a computer person to work with him. And then there's another computer guy that I use for my regular digital prints. I just like to play to people's strengths, and find the people who have the strength to do what really works, and go with that. I'm not a technician. I mean, maybe I should be embarrassed by that, but I want excellence in my work. So, for instance, I find who is the most excellent Photoshop person, who can help me tweak my images. Ninety-nine percent of the time, there's no need for any tweaking.

I don't feel I've lost anything [with the switch to digital]. In the beginning, I had issues—the digital sensors are a little flat. But the digital does not make a picture, as film does not make a picture. There's no camera, there's no lens, there's

no sensor that makes a picture, only your eye can make a picture. These are merely tools. So, for me, knowing the slight limitation of digital, everything else being perfect, I work around that. I'm happy with what I'm getting, because my mind factors in the issues that I think I have to look out for.

The reason I started photography was because I was in love with my great-uncle and my great-aunt as a child, more so than I was in love with my mother and father. And when I went to Tuskegee, I was in business management, and I had to hire P.H. Polk to make some pictures for me. In his studio I discovered he had these pictures of old people from the '30s, very distinguished, very dignified images. It made me think, wow, they look like my great-aunt and my great-uncle, but I have never seen a picture of them. They were too poor to have a picture of themselves. And I thought that they should have a picture. But as a student, I did not have the money to hire Polk to go 100 miles to my village to make pictures, so I asked him if would he teach me. It took me a year to get competent enough with the Nikkormat to go home and make those pictures. The reason I started

as a photographer was from the heart. I wanted them to see what I felt about them. So I gave them those pictures.

When I go to Africa, I'm pretty much doing the same thing. When I go to a village, I factor in giving maybe 100 Polaroids the first day. For me, it builds bridges of trust. I figure, by showing them a photograph, my Polaroid of them, it lets them know how I see them, and allows them to decide whether or not they trust me to make their picture. And I begin by coming and giving, as opposed to asking them for something. I used to tell people, if you go to Africa and you see old Polaroids sitting around of somebody, they'll probably be mine. Now that things are in digital, when I photograph, I won't show everything, but I'll pick out one or two of what I think are the strongest images, and I'll show them to them [in the camera]. And this is after they've been paid our agreed-upon price, and they're all excited, and they want their friends to see it, and I'll show it to their friends. I'm thinking about taking a [compact digital photo] printer, but I'm not completely happy with the printers that are out there yet. But at some point I'll probably take one of those small printers with me.

HOWARD HOPWOOD
CHAIRMAN, HARMAN TECHNOLOGY LTD., MAKERS OF HARMAN PRODUCTS AND ILFORD PHOTO TRADITIONAL MONOCHROME PHOTOGRAPHIC PRODUCTS

Interviewed June 1, 2012, at the Harman factory in Mobberley, Cheshire, UK

A layman's overview of photochemistry? That's quite a challenge. The basic premise of all photography starts with dissolving silver. The favorite way of doing it is to take silver bullion and dissolve it in nitric acid, and you end up with silver nitrate, which is just a solution. And then you take a solution of, say, sodium bromide, or sodium chloride, the common table salt, and if you mix one of those with silver nitrate, you end up with a whitish powder. A precipitate comes to the bottom of the liquid. And the thing that's magical about that powder, that silver halide powder, whether it be silver chloride, silver bromide, or silver iodide, is that if you shine a light on them, the crystal structure breaks down and you end up with silver metal. You end up with the halide [bromine,

Howard Hopwood, 2012

chlorine, or iodine] coming off the silver. The two separate. So you end up with a black silver deposit, and that is the basis of all photography.

After you expose your paper, the problem you then have, of course, is you've got this black mist that becomes the black part of the photograph during development, and this other stuff you haven't exposed. It hasn't been exposed to light, so you have to get rid of it, and that's what fix does. Thiosulfate dissolves the bit you don't want, so the highlights in your photograph stay white, and then you wash to get rid of any of the things you don't want left in your layer. And that is a very basic description of how photography works.

The way that's changed over the years is that they used to just pour these solutions in and stir them with a paddle. That is literally what Ilford used to do, in fact. In the original days of Ilford, they used silver teapots to actually pour the emulsion onto glass plates. That was the original coating process.

To control the coating process, you want to suspend those silver halide crystals in something that holds them apart, because you don't want them in a lump at the bottom. So you use gelatin. Gelatin is just like table Jell-O. And you pour your solutions into a solution of gelatin, and the crystals form, separated and suspended in this gelatin, which sets when you chill it. When you warm it up, it goes into a liquid. That again is the basis of the photographic process, because you want something you can store in a cold store to keep it stable, and then when you want to coat it onto film or paper, you warm it up and it turns into a liquid.

Then, not by using a silver teapot anymore, but by using something we call cascade coating, you coat the layers on the film base or the paper base as it goes past, so you pump the liquid out, and the paper or the film goes past, and it drags it away. And then, of course, you have a molten layer of gelatin with silver halide crystals in it, which you then want to set, because otherwise it would just flow off the base. So you then send it over a chilling plate, and then into a very complex dryer, and that is where the clever bit of photography is. You dry that gelatin in a way that makes it set and dry in a structure that does not affect the crystals, so they behave in the way you want them to. To stop the thing then falling off when you make it wet, you add a hardener, which crosslinks the gelatin, holds the gelatin together, and literally sets it solid, so that you can dip it in your developer and it won't fall off, and you can wash it for hours on end and it won't fall off. So it's quite a complex process, but it's all done now in a very controlled, computer-controlled fashion.

JEFF JACOBSON
PHOTOGRAPHER

Interviewed September 29, 2009, at his home in Mount Tremper, New York

I started taking pictures when I was a lawyer in Atlanta, in '73. I was going crazy being a lawyer. I just didn't like it. I was an ACLU lawyer and quit practicing law about a year after I started taking pictures. I liked the way photographers lived their life; I liked that they could use a camera to get into other situations in other people's lives, and so I just thought I'd try it as a hobby, and I just got swept away by it. You know, it was a different time, the '70s. I wasn't married, I didn't have any kids, I had a little money—very little, when you think about it—but you didn't need so much then. I lived in my van. I took one workshop with Charlie Harbutt and started shooting color about two years later. Then I started shooting Kodachrome, and have been ever since.

It's hard for me to speak about color in digital, because I frankly don't know. I mean, I shoot it, when I have to. It seems to me that digital is about post-production. That's where the magic happens. Kodachrome's about the moment of shooting. They're two very different mediums. What bothers me about the way digital looks is that it tends to even everything out. It's very homogenous. The beauty of it is that you can see into

shadows and see into dark spaces in a way that you can't with film, but it's a problem, too, because everything gets evened out. It's not like with a transparency, where you have intense highlights, and intense shadows. It's harder to get that in digital. The truth of the matter is, I just don't know about digital yet. We'll see, because I will probably start using it when I'm out of film.

I don't know the difference, really, between grain and what's called digital noise. I love grain in photographs, you know: I push Kodachrome to get the grain. But people say, "You've got to get rid of the noise." Well, is that true? I mean, when I do start playing with digital, that's one of the things I'm going to mess with. I'm going to shoot it the way that everyone says don't shoot it. I want to go against what is supposedly the strength of it, because I don't like the strength of it.

To me, the great benefit and genius of digital technology is in scanning and printing. I find scanning and digital printing very liberating, because it gets me back to a place that I had when I first started photography, which is taking pictures and

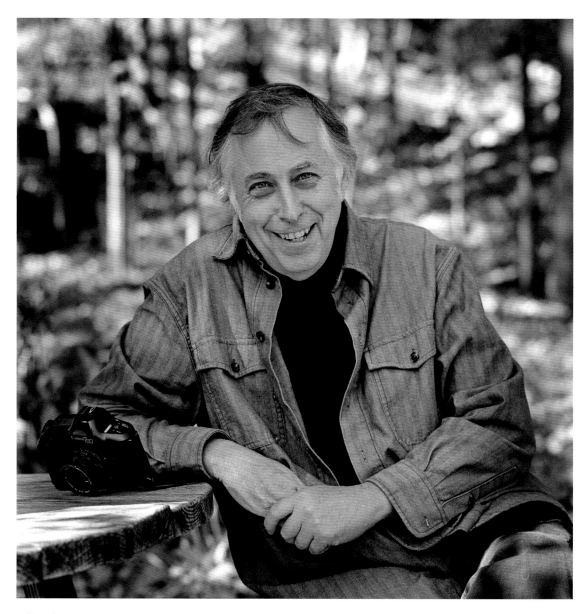

Jeff Jacobson, 2009

Sid Kaplan, 2008

then printing them. And no, I'm not in a darkroom, but there is something wonderful about that rhythm, and seeing them as prints. And that's beautiful.

Editing, I think, is every bit as creative an act as photographing, and when I teach, really what I'm teaching is editing. The editing process is a really magical process, and for me, one of the biggest problems with digital is that it teaches young photographers terrible habits, because they're editing sometimes right after shooting. They're looking at the back of the camera and they're deleting stuff. The closer you are as a photographer to the event of taking a picture, the less perspective you have on the photograph. And the worst possible moment to be editing your work is right after shooting. It's a huge problem for young people that never started with film. That whole problem with editing digital, it's perhaps the most serious problem that digital photography presents. When I teach, I make the students tape up the back of their digital cameras. I say, "Do not look. I don't want you looking at what you're doing. I want the process to be going on in the unconscious, not in the conscious." Still photography used to be, you go out, you may be on the road for a week, two weeks, a month, whatever, you wouldn't see anything. So the process is going on in your unconscious, and digital brings that up to the conscious. I think that's a real change in photography, and I'm not at all sure it's a change for the better.

SID KAPLAN

PHOTOGRAPHER, EDUCATOR, AND MASTER PRINTER FOR ANYONE AND EVERYONE, INCLUDING EDWARD STEICHEN, ROBERT FRANK, WEEGEE, LOUIS FAURER, ALLEN GINSBERG, W. EUGENE SMITH, CORNELL CAPA, PHILIPPE HALSMAN, AND DUANE MICHALS

Interviewed November 18, 2008, in his darkroom in New York City

When I was a 10-year-old kid, I saw a black-and-white print come up in the developer. I was hypnotized. I just wanted to keep doing it. Basically I'm a slave to my hobby. My hobby is doing my own photographs, having a place to print them. So where does the money come from? I teach [traditional darkroom techniques at the School of Visual Arts] one day a week. I do printing for other people and hope that's enough to keep the hobby going. I never wanted to do it for money. It just takes all the fun out of it. It's a lot of work being a professional photographer. After a while

you are a photographer going out there doing somebody else's ideas. For myself, it was just more fun just to go out there and take pictures. I don't know when I stopped hunting for pictures and just started carrying a camera with me as I do my daily routine, hoping eventually a good picture would find me. That was my original passion. But you have to pay the rent, so that's where the darkroom came in. It's not a luxury commercial darkroom like some of the big labs, but it's just enough to be able to do my own photographs and occasionally take in some extra laundry.

I do digital a lot. People see me on the street with a camera and they got a digital, and they ask me to take a picture of them in front of Times Square, or by the Empire State Building, with their digital camera. So I have been shooting digital. Would I want to do it myself? No, because number one, it's not so much the digital camera, it's all the paraphernalia you got to have to go with it: all kinds of electronic equipment to play back your chip, and then before you do your chip you got to put it into download, and you have to have all that stuff. And re-skilling yourself when you're 70 years old—it can't be for me. I don't even know [where to find] the on and off switch for the stuff.

What's happened with the digital is that it's gotten homogenized. You think your digital print is so individual, but you'll get the same print from somebody else's printer 100 or 1,000 miles away. In the darkroom, no two people are ever going to make the same print. Too many variables. To begin with, no two people ever make the same negatives. Add the variables with the enlarger, the brands and surfaces of paper available, the amount of different developers and chemistry available, and all of a sudden you got a couple hundred combinations to deal with.

I've often thought about what makes you do this thing. One time my grandson was here and I was printing. So we're talking while I'm printing, and I started saying, yep, I've been doing this from 1955 till now, 22-hour days, it just goes on and on. And he's listening to all of that, and then at the end he says, "When you're doing that all that time, what are you thinking?" And I said, "Everything, from the minute I was born to what I gotta do for the future." Unless you're talking to somebody else who does this thing there's no way of ever explaining why you do it.

In some ways I think right now I'm exactly where I was 60 years ago, where anybody that had a wet darkroom in their house was somewhat unusual. People say, "Oh, you've got a darkroom in your house?" And I say, "No, the whole house is a darkroom, and I just found a corner to sleep in." The adventure, though, is still getting a good picture. If I thought about all this

other stuff, about where it's going or where I'm heading, it wouldn't be fun.

I'm at the point that it's time to start wrapping things up. If there's no more developer around, no more Dektol, no more paper, well I got my 60-year merit badge. But there's still a few more negatives I'd like to print.

EDWARD KEATING
PHOTOGRAPHER

Interviewed November 25, 2008, at his home in New York City

I've been a photographer here in New York for close to 30 years. Started taking pictures in 1981. Spent nearly 12 years at the *New York Times*, staff photographer. And I started out as a street photographer, and tried to maintain that as a journalist at the *Times*, and I'm still, in my heart, a street photographer.

With the [rangefinder] Leica, what you're seeing is sort of an approximation of the photograph. You're not looking through the lens, and so every picture is a leap of faith. The fact that you don't know what you're going to get sort of frees you from it. It takes you away from the exactness. For me, I wind up paying much more attention to what's going on. Then I'll let the chips fall where they may. If I can get the moment from the right perspective, the picture will take care of itself.

I don't use a meter, and I don't trust the camera meters. I used to use a handheld meter, and then I was at the *Times* and I lost my meter, so I went to my boss and asked for a new meter. She was upset, because I had lost a cell phone—I'd already lost a few things—and so she gave me this meter and said, "Don't lose this." So I lost it two weeks later. Then I was scheduled to go to Vietnam on a story for the Sunday magazine with Tim O'Brien. And I realized that whenever I took those meter readings I knew it anyway, it was just sort of a confirmation. So then I figured, I really don't need it. I really do know the light. And no better way to test whether I really do than to bet this entire assignment on my ability to do it. That was my first time working without a meter, without a net, and it came out beautifully.

I was the last photographer to go digital at the *Times*, or second to last. I didn't want to have anything to do with it, and it wasn't that I was so much against digital per se;

Edward Keating, 2008

Thomas Knoll, 2012

I just didn't want to give up my Leica. I liked using the rangefinder, and it's just a totally different way of seeing, between an SLR and a rangefinder. I felt that with an SLR I really had one hand tied behind my back. I was [at the *Times*] in '91, and I got my first digital camera two weeks before George Bush, before W was inaugurated, and I had two weeks to get up to speed on the whole digital thing. In fact, I wound up tanking that whole assignment. It was like the one time in like 11-plus years that I didn't make first edition. In other words, I wasn't ready, and the paper went to press without me, and I just had a complete, you know, digital meltdown that afternoon, right on deadline.

Digital is almost too real. You know, it's too lifelike. It looks exactly like things look in reality, and I'm not interested in just showing things exactly the way they are. I'm trying to make a photograph. I'm trying to get at something that's underneath the facts, behind the facts. It's an interpretation. It's an idea.

In every generation, photographers have had to deal with technological change. I've tried to span the gap, because I don't want to be left behind, and so I've kept up with the technology up to a certain point. But I know what I'm good at, and I've held on to the film. I've done it as a photographer, as an artist, and also as a journalist, thinking that black and white is always going to have a certain power and impact, regardless of what comes. I mean, black and white sort of hits you in the gut. Color is more ethereal and then more emotional, I think. Black and white is more intellectual. It's more cut-and-dry. That'll never become obsolete.

THOMAS KNOLL
CO-INVENTOR OF PHOTOSHOP

Interviewed October 24, 2012, while he was in New York City for the exhibition Faking It: Manipulated Photography Before Photoshop *at the Metropolitan Museum of Art*

I waited to get a digital camera until the six-megapixel digital SLRs came out. I had seen some of the very early digital cameras. Apple had a very early digital camera, but the quality was primarily video quality. They basically put video sensors in a still camera body, so the resolution was very low. It didn't really have a whole lot of appeal to me. But suddenly, when you could have a digital camera that produced very similar or even better quality than you could get out of film, it

became interesting, and I purchased a camera at that time.

In my mind, there is nothing magical about film anymore. It's just another scientific method of recording images. My belief is that if you have a high enough resolution, high enough quality digital image, it's possible to simulate all of the chemical effects that you could do in the past. That's if you want to spend the time figuring out a physics model for whatever effect you're trying to simulate. In my personal photography, I'm more interested in trying to produce a more accurate, clearer, more perfect image. I don't personally try to simulate the artifacts of old. I try to produce the best image I can with the newest technology.

I don't consider myself a particularly good Photoshop user. I tend to use it at a pretty basic level in my own work. I tend to use either the Camera Raw plug-in or the Adobe Lightroom to do most of the image processing on my personal photography. I know Photoshop and how to do a lot of other stuff, obviously, because I wrote a lot of that code, but there are lots of people that are much better at Photoshop than me in the world.

JEROME LIEBLING (1924–2011)
PHOTOGRAPHER, PHOTO LEAGUE, AND DISTINGUISHED EDUCATOR

Interviewed August 11, 2009, at his home in Amherst, Massachusetts

I photographed Brooklyn, Bensonhurst, the East Side, the immigrant experience, the people that I truly understood—their rhythms, their speech, their language, their songs, the streets. I didn't know Park Avenue, and I didn't know Central Park West, but I knew the East Side, and my grandfather was still alive. And I suddenly said, my, this is where I want to be. I wanted to make pictures of what I thought were people who were beautiful and striving, and struggling with the least amount of privilege. What is the totality of the world? Where's the pain, where's the struggle? And maybe pain and struggle, and sometimes beauty, is what I've been photographing.

When I came aboard, 1945, or '46, film—the silver process—was the one that was in use, and that's what I learned. If there was a mystery, or a relationship, or a touching that this silver was giving me, I just accepted it, I didn't know what was happening. I've heard discussions where people have said, "Well, the silver has 4.2

Jerome Liebling, 2009

to 2.6, and this digital only has 8.9"—I don't even know what the hell they're talking about. I haven't found the difference, though I've watched the experts look at the silver and look at the digital, and tell me. I said, I don't see it, buddy. So I can't fault digital, nor can I tell you that there was a secret kiss from silver that occurred.

When I came to Hampshire College we built a facility, it was 1975, and we said, oh my, look at this wonderful department we have, and we built a wet darkroom. What's the term, "analog." It was a wet darkroom, and we were so proud, and we had all the rooms, and all the enlargers, and now they came around recently and said, "We want to get rid of the darkroom, we don't need it anymore." And I didn't know what to say, you know, it was something that I always used. You can't do that! Shouldn't everyone experience it? I don't have the answer to what to do. You say, why do they have to have roll film? Why did they have to go back to the daguerreotype? Nobody asked me to make a daguerreotype when I was going to school. There are instructors who say this is good for you, it's like taking your cod liver oil, do the roll of film, get into the enlarger, and see what's going on.

If you talk to Eastman Kodak, no, film does not have a future. The question of progress? I always felt that "progress" was a slippery word, and it didn't necessarily mean "progress." It's just that, buddy, I can make money with this thing, and that's what I'm going to do. Harvey, it's past tense, the computer is here. It is here. And how deeply it's here, and how it's changing the facts of life is what you're searching for. People say, "Hey, Jerry hold still," and they take out the telephone and they take a little picture. I don't know where it goes or what happens to it. I think within photography, the cusp is over. The daguerreotype is dead, the dry plate is dead. Can you go back and make a dry plate? Yeah. A wet plate, or whatever they call them, an ambrotype? Yes. But so what? If I walk through the streets with my Rollei, people say, "Oh, is that a new camera?" I think the scariest term was when somebody said, "Oh, Jerry, you still practice alternative processes." That the negative, and film, is an alternative process? It's not a frontline process! That hurt. [*laughs*] I think if you want to make pictures, you want to be a painter [with the digital], well that's fine, go ahead and do it, but don't call it photography. To me, photography meant there was a response to the fact of life. And that fact of life is still there. If the digital is going to change and alter that, it's not what I'm interested in.

NATHAN LYONS

PHOTOGRAPHER, DISTINGUISHED EDUCATOR, FOUNDER OF THE
VISUAL STUDIES WORKSHOP

Interviewed October 17, 2009, at his home in Rochester, New York

I was born in Jamaica, New York, in Baisley Park, and have moved subsequently out of the environs of New York City. I did four years of military service in the Air Force as a photographer. Returned to complete a degree that I had started earlier, was heading to Chicago to study with Aaron Siskind and Harry Callahan, but stopped off in Rochester to get a job so I could afford to go to Chicago. And had only expected to be here for a year or two. But that was over 50 years ago. It shocks me to even say that. I came in 1957 and started to work at the George Eastman House, had 13 pretty challenging years there before I founded the Visual Studies Workshop. And I retired from the Workshop in 2002.

One of the things we helped to contribute to in the early days of the Workshop were alternative processes, and we reprinted earlier manuals so they'd be available for students, and we generated a vast number of workshops in blueprinting and gum printing and cyanotype printing. It's been a part of a tradition in Rochester that you sustain all these processes. I mean, there are still people that are making daguerreotypes. So I don't see it as a question of obsolescence, I see it as a question of preference. So the fact that digital comes along doesn't mean I'm going to bemoan the loss of something else. It's just something that needs to be incorporated.

I think the kids are further along than possibly we were years ago when we first came to photography. They're visually a lot more sophisticated. The tool affords them a viewpoint that is quite amazing, and I'd throw in cell phone imagery as well, because I think we're seeing a number of artists begin to work with cell phone imagery. There's an intimacy to it that's really quite amazing. The distinction in my mind is not that there's something new going on here, because the model for the digital image is the photographic image. Digital will eclipse the conventional systems we've used since the beginnings of photography. But I'm quite sure people had some of the same anxieties shifting from the daguerreotype to collodion. To me the bottom line is, *what* images are being made—not *how*, but the images themselves.

People were capable of making very dumb pictures with conventional media,

and they'll make dumb pictures with digital media.

While I still love to work in a darkroom, I am intrigued by the whole notion of a dry process. You know, we had glimmerings of it certainly earlier with Polaroid and instant systems, and that's what we've got now, a highly sophisticated instant system. I have a digital camera, but it's still in the box. My wife, Joan, shoots digital, and I shoot film. We're in a physical situation where she gets an image right there, and I'm trying to stretch that goddamn film so I can get an image. She's got an incredible representation of what was there and, you know, I may or may not have it. Especially in low light levels, I'm just intrigued by what's possible digitally.

I honestly think that we tend to worry too much. And all the protests that people can bring forward...what good is that going to do? Industry has made the commitment to move in this direction, and industry dictates what tools we have to work with. So you either stay ahead of the curve or you're behind. But I don't think it's something to worry about. I don't know what kind of world we're entering, but it's certainly faster, more accessible. And I can't see it stopping or slowing down. I hope I'm around long enough to see where it gets us to.

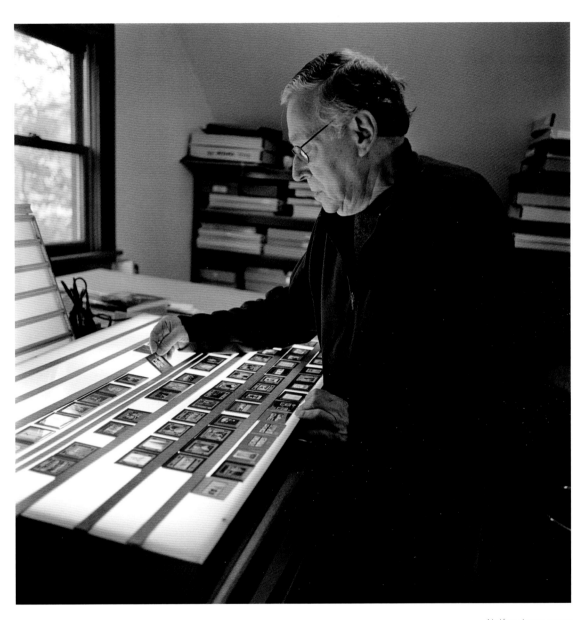

Nathan Lyons, 2009

SALLY MANN

PHOTOGRAPHER

Interviewed November 23, 2012, at her home and studio in Lexington, Virginia

I started when I was 17 with a Leica that belonged to my father, and he also had a little 5x7, beautiful little Eastman 5x7 camera that Larry fixed up for me—taped up the bellows, got the track unstuck. It was right about the time we were married, 1970, and he said, why don't we try this? I'd never worked with a view camera before, so we started messing with it, and it was difficult at first. The lens was uncoated, there was a flare on the negatives, and they were flat. Now, of course, I look for uncoated lenses, but then I wanted all of my pictures to look like Ansel Adams's, because after all, I'm using a view camera, right? But they didn't look like Ansel's, and it was very frustrating, and I'm easily frustrated, impatient. So it was a rough start, but I persevered.

I packed up that little 5x7 in a Samsonite overnight case that my grandmother had given me, very 1950s, white with a beautiful scarlet taffeta lining. I put the camera and some leaky old film holders in it, and we carried this cute little Samsonite case to Europe with us, like I was going to a sleep-over, and I took pictures as we traveled. It was in England that I saw my first bromoil print. My recollection of a bromoil is it's a print made on very pebbly paper

that's bleached out, and similar to an etching, you can then reinvigorate the print with ink. So you stipple the ink on, and you get a picture that looks just exactly like the pictures I'm still taking today. This was in, what, '72, that I was trying to make these bromoil ink prints. They look like gravures, really. So that's where I started. I just love that dark, tenebrous feeling in an image.

In terms of making the transition from silver film to wet-plate collodion, there was an intermediate step. I discovered a box of expired ortho film, and I found a funky lens that let in way too much light and flare. Then I developed it in a certain way, and in doing so, I could make something that looked like a collodion. And, in fact, it almost fooled the Ostermans, the collodion gurus. I knew I was close, aesthetically, but no cigar, so from there, I made the leap right into wet plate.

The process is extremely important. If I have an idea, I look for the right process to bring that to fruition. I knew exactly how I wanted all the Southern landscapes to look and feel, and I just had to find the right process. On my trips, in the back of the truck, I took regular silver film, 8x10, wet-plate collodion, and I took

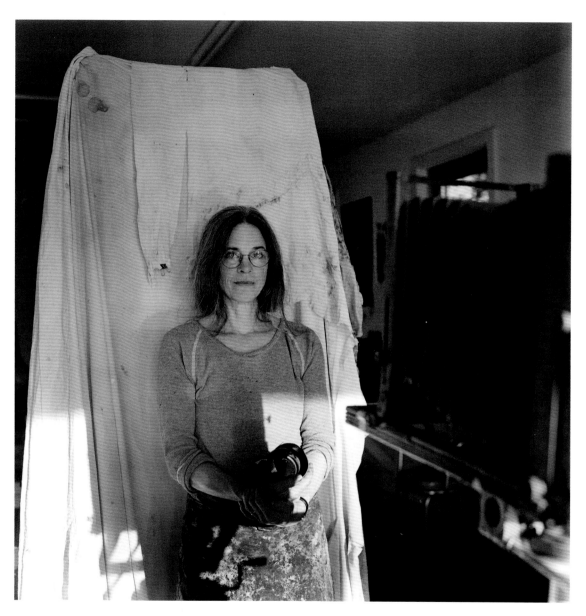

Sally Mann, 2012

ortho. So, each time I would shoot something, I would shoot with all different kinds of film, just to see what I would get. Wet-plate collodion does exactly what I want it to do. You pick your materials to suit your aesthetic and your vision. Sometimes it's the other way around. Sometimes the process informs you what your vision really wants to be. I've had moments where I didn't know what I was doing, but the film showed me, or the material showed me.

There's something so earnest and so honest about wet plate, and it's a perfect foil, I guess, for my romantic, passionate personality, to have this very crisp, just-the-facts-ma'am kind of process.

Apparently, Peter Galassi went after me and said, "She's completely irrelevant. She uses these old processes to make her pictures." It shouldn't make any difference what material you're using. Was it de Kooning who said, "I'd use mayonnaise if it was the right color white"?

There is something about this process that's a little more contemplative. And also, here's another thing about these long exposures, something goes on with the eyes. There's a certain sadness and depth that's revealed in someone's face, I think. You know you're sort of sitting for the ages, and I don't think an iPhone picture makes people think that they're sitting for the ages.

CONSTANTINE MANOS
PHOTOGRAPHER

Interviewed October 7, 2009, at his studio in Provincetown, Massachusetts

I began my photographic career in the junior high school camera club at the age of 13. I fell in love with the darkroom. I've been in the darkroom all my life, and I love making prints. After my last big black-and-white project, my personal work went into a slump. I felt that I was not finding good black-and-white pictures anymore. What saved me was color. I started going out on the weekends with my Leica and some Kodachrome. And

it opened up a completely new career. It's very thrilling to find something brand-new late in your career that's very different from what you did before. My first color book, *American Color*, was published in 1995. When I went from black-and-white film to color film, I mastered the art and science of making Cibachrome prints. It's a very difficult, complicated, toxic, and smelly process—but the most archival we had at the time.

Constantine Manos, 2009

At the time digital came along, I was doing a lot of workshops. All my students said, "Oh, when will you go digital?" I said, "Never. I will never abandon film. I will never go digital." And people really believed that, and I believed it, too. Then I started seeing what was happening and seeing how wonderful it could be...and I just fell in love with it. I'm a Leica person from way back, from the beginning. When Leica came out with their first serious digital camera, the M8, they sent me one to try out in 2006. I was smitten. I put my wonderful collection of Leica film cameras in a bag and put them in a big safety deposit box in the bank. And that's where they are now.

In 2007, I was taking the digital camera and the film camera with Kodachrome in it on trips to photograph and look for pictures for a new book, *American Color 2*. And I even have some situations where I was shooting both cameras. You can definitely see the difference between digital and Kodachrome film. Kodachrome film is a little warmer, a little more three-dimensional. And digital has a sort of a flat look. I've experimented with an application that allows me to apply Kodachrome grain to digital. And it is very, very impressive. So I think if someone wants to have that look, it's possible. As far as the ethics of applying a film grain to a digital

picture, I think a photographer has the right to do anything he wants to make his pictures look the way he wants the world to look, because he's presenting his vision of the world to his viewers. Changing the appearance of a print does not change the basic information in the image. I'm beginning to think that the digital pictures actually are sharper than what the eye sees. I like for pictures to look the way the eye sees the world. I look around me and I don't see it ultra, ultra sharp.

I don't believe that a photograph exists until it is a print. Photographs on the Ethernet and the computer and on hard drives are not real until there is an actual print on a piece of paper that you can hold in your hands. To me, a print has always been a sort of one-on-one experience as a viewer. Now I'm at the biggest size I presently care to make, which is 24x36. It's manageable not only to handle but also to look at as a viewer. I've been to some exhibitions in New York where they have 60x90-inch prints in big spaces and people are wandering around in the middle of the room looking at these things as though they're old-world master paintings. And a certain intimacy is lost, that you have where you walk up to something and you have a one-on-one experience. I hope it's a passing phase to think that a photograph has to be big to be good.

PAUL McDONOUGH

PHOTOGRAPHER, DISTINGUISHED EDUCATOR

Interviewed September 28, 2009, at his home in Brooklyn, New York

I went to art school for painting and art direction at the New England School of Art in Boston. I came to photography through Robert [Frank]'s book *The Americans*. Looked like a good way to work, looked like a good way to get me out of the studio. It's amazing what digital does. I'm really in awe of it, but as far as my own needs, what I shoot with film satisfies me. And really, I'm still waiting for some definitive point where you don't have to start thinking about buying new equipment every two years. I'm used to having a camera for 30 years. My enlarger is 30 years old. I bought it from Elliott Erwitt years ago. It still works fine. So it's finding the right tool and then forgetting about the technology. I don't want to think about equipment. The equipment itself, outside of its use, is boring.

I never went to school for photography. Of course, 40 years ago, there weren't that many photo classes or programs around. I got my first teaching job at Parsons, 1970. I substituted for someone else and took a few classes from Garry Winogrand and Tod Papageorge, and eventually I found a position at Pratt. They were looking for people, and Arthur Freed and Philip Perkis were there, running the new department. Photography was always adjunct to the painting and the com d [communications design] programs. They all had their own darkrooms, but no one was really teaching it. They had a technician that ran the darkroom, and students could learn how to print there. When the photography degree programs started, that's when the whole thing changed, when you could actually start making a living doing photography. Of course, now, the problem is, there are so many schools with programs. There's a surfeit of MFAs looking for jobs—looking for my job, you know, and I'm ready to give it to them. My students love being in the darkroom. They love getting away from the screen, because their whole lives are attached to that computer screen. You know, whatever you do—your banking business, your dating, your everything. So you go into a darkroom, something physical, and it's different.

One thing I'm trying to do is just get my older work in print. I'm also printing stuff I shot recently. I'll put it in one pile, and the other piles are the archives. I'm an archivist now. So I go back and forth. It's like you're dividing yourself, and one part is trying to preserve and collect, while the other is still exploring.

Paul McDonough, 2009

Susan Meiselas, 2014

SUSAN MEISELAS

PHOTOGRAPHER, FILMMAKER, CURATOR, DISTINGUISHED EDUCATOR

Interviewed June 13, 2012, at her home in New York City

I've been a freelance documentary photographer all my life. After my *Nicaragua* book in 1981, I started to work collectively with other photographers. Long before aggregating and curating on the Internet, I was trying to create collective expressions and testimonies, which really began with *El Salvador: Work of 30 Photographers*, and then a book with Chilean photographers, *Chile from Within*, and then a big leap to *Kurdistan: In the Shadow of History*, which was probably the most ambitious project, partly because I had lived a very short part of that history. Whereas the El Salvador book was a portrayal of four years. During that time many other photographers had come and gone; a few of us had been there through that whole period. And with Chile, I had very little experience there, so it was mostly facilitating and working with Chilean photographers to make sure their history was told by them. In a way, I was just really setting the stage for them.

In the '80s, the people who were making history often didn't have the means of production. Some Nicaraguans documented the early stages of the insurrection, but the opposition newspaper was bombed and its archives were destroyed. In the later years of the Revolution, they continued to work for local papers, and some even became stringers for international wire services as well. In El Salvador, they were documenting their own insurrectional process and releasing news directly to the media, including through a very powerful radio station, *Radio Venceremos*. The problem was, they weren't legitimate in the eyes of the Western media. Now, the Western media are more dependent on local voices who do have the means to distribute through the Internet. The choice is whether or not the Western media can effectively scrutinize and determine whether or not something's authentic. But getting the testimony direct from the field, from the participants, in the early '80s, was unacceptable—that wasn't valued. And that was very preoccupying to me. Who has a right to tell a story? I don't think it's an insider-outsider issue. I think it's a matter of where the insight can come from, or what kind of relationship creates the possibilities for that insight.

For the project in Kurdistan, the technology wasn't there at the beginning of the '90s, so we didn't have smartphones and automatic uploads. Those really fundamentally changed the relationship of authoring and curating and participation,

et cetera. In some way, I like the fact that in Kurdistan I was using Polaroid film and people could see what I was reproducing of their family or in studio photographs, and choose to participate in a very physical sense. They were bringing the photographs from their albums, bringing them to my lap in their backyards. It was very physical, and I miss something about that physicality in the digital age.

Encounters with the Dani, which I did just on the cusp of 1999–2000, in that book, the process of collecting and printing was fundamentally different. It was astounding how fast it changed by the end of the '90s. So whereas I began the Kurdistan book in '91, it was designed on Quark in my studio, only with "for placement only" indications for the photographs. It was delivered digitally, but the printer used film plates. The book was published in '97; I began the Dani book soon after that, and already we were starting to be able to transmit files electronically, which meant that I was actively researching on the web, not just in backyards. For the Dani book, the layout files went straight to the press. It was astounding, the speed of that transformation. I'm not sure I'd even caught up with what was happening, frankly. I just was responding to it, and trying to create form with it. So, in some ways, I think *akaKURDISTAN* [a collaboratively created website] was the last point of that dialogue that I feel I was in,

trying to understand what people can contribute from the field in an ongoing way. Now, I continue to think about how you create frameworks for that kind of contribution. How do you keep the balance of the authoring in relationship to the multitude of other voices? That's one of my principal questions.

I've been someone who embraces technology and enjoys exploring it, to figure out what it can do, along with what I can imagine. The question is, can you continue to invent a role where you belong?

And maybe now I'm not quite sure where I belong anymore, both with my authoring, or even with the collective framing process—my collaborative process. That's part of a complete reevaluation, crucial to do now.

If the iPhones are mostly the source of the billions of images we're seeing uploaded daily, they're mostly familiar subjects, friends and so on. Are the people who take these photos interested in other people's perceptions? Whether or not you're a "storyteller," you're making images. How interested are you in what the image is of? How is that image functioning in relation to a larger community? I don't know what it means to just put things up into the ether of iCloud, Flickr, or whatever—storing life up there, instead of living life down here.

PAUL MESSIER
PHOTOGRAPH CONSERVATOR

Interviewed April 27, 2011, at his conservation studio in Boston, Massachusetts

In 100 years, what will persist, a digital file or a silver-based photograph or negative? I think, all things being equal, it's the silver-based photograph. I don't think it's much of a contest. There's just too much that can go wrong with the digital file. First, it's machine-readable. I mean, as long as human beings have eyes and the sensory equipment associated with the brain, they'll be able to look at a photograph, interpret a photograph. A file, if it exists, is a series of bits, and you're going to need some sort of machine to read it. Not only that, you're going to need a machine that has the capabilities to accept whatever media the thing is saved on. Will there be USB thumb drives in 100 years? Or computers that will be able to use hard drives made in 2011? No, there won't. You would need to assume some sort of very active migration process to keep those files alive. A photograph can sustain relatively benign neglect. You can put it on a shelf and it will be there waiting for you in 100 years. Sure you can put some hard drives on the shelf and they'll be waiting for you in 100 years, but will you have the capabilities, the desire, the budget to read that material? Probably not.

I think we're at the end of an era, but that doesn't really upset me at all. Imaging with light-sensitive materials is still going on. A charge-coupled device is a light-sensitive material just as a silver halide is a light-sensitive material. I think there is a lot of nostalgia right now in a way, looking back mournfully that we're losing this, and I can relate to that. But it doesn't bother me. What would bother me is if the knowledge of the materials was lost—if we lost the understanding of 20th-century photography, what it was to make a photograph in the 20th century. And what I'm trying to do is to preserve that knowledge.

So the transition to digital is, I think, more of an evolution than a revolution, honestly. I think it's very dramatic, however. There's a lot of discontinuity with digital materials relative to wet, chemical-based photography. But it doesn't upset me. In fact, I think this is a really exciting period to care about photography, to watch it change. It's kind of a privileged position to be in. I mean, arguably, we haven't had a transition like this in the history of photography.

Paul Messier, 2011

ALISON NORDSTRÖM

INDEPENDENT WRITER/CURATOR

Interviewed October 17, 2009, at George Eastman House, when she was Senior Curator of Photographs

I think we have changed the nature of how we make photographs, which has caused us to change the nature of how we keep photographs. But I don't think that has yet changed the way we think about photographs. And even the way we make photographs—it's changed technically, but not culturally. And that's not surprising.

[Marshall] McLuhan made the very good point that with each change in technology, it takes about a generation for the vocabulary to catch up. So we call our computer's working surface a desktop, and it's full of files and folders and pages. There's no reason why we need to call them that, except that we don't have a more appropriate vocabulary. We're borrowing it from the preceding technology. And I think a 19th-century family album functions culturally pretty much like the 300 pictures you have on your phone right now, but we are going to end up feeling differently about them, because eventually, we'll use them differently. If it's important, we won't forget it. If it's not important, we will.

The language that we bring to digital photography evolves from the language that we brought to other photography, which itself evolved from the language that we bring to painting, which means that we think seriously about photographs that we can talk about in terms of tonality and strong diagonal lines, and we don't pay much attention to photographs like passport photos or mug shots, because we don't have a vocabulary for addressing them. We're stuck with what the art historians gave us. And I don't think that a specific language for talking about digitally produced or digitally printed images has appeared on the scene yet. I look at a lot of contemporary photography, and it's honestly difficult for me to say whether that's a photograph or not, or should I consider it illustration?

Anybody can make a picture now. Ninety-nine percent of the American population is walking around with a camera in a pocket or purse, 24 hours a day. I don't know what digital tells us about ourselves. We still want pictures of the faces of people we like.

There's been discussion in my field about, you know, let's start in 1839 and let's end in 1980 and just sort of say this was this

Alison Nordström, 2009

time of the chemical photograph. But I'm not so interested in the photographs as I am in the people who made them, cared about them, or didn't care about them, and I don't see why I should shut the door on the 100 pictures on your iPhone. And again, technically, we can figure out how to save your phone and how to save the pictures on it, and we can interpret them in the context of photographs people have been treasuring of people they love ever since they could have a photograph.

PLATON
PHOTOGRAPHER

Interviewed August 24, 2011, at his studio in New York City

I started in London as a graphic designer. My father was an architect, so I was trained really as a craftsman, and to respect craftsmanship, the art of making something. Design has always been a huge part of my ethic. For me there was never a distinction between lettering or architectural detail and faces, hands, people. It's all a visual, graphic language that has to be concise, bold, and in-your-face. For the tools, all my main portraits are done with a Hasselblad. If I'm shooting 35 millimeter, I like Leica M6s. I still shoot film. Most of what I do is discipline, and it's not just technical. If I'm shooting on film, I've got 12 exposures, and I have learned to pace the event from the first exposure to the twelfth.

When I photographed [Muammar] Gaddafi, I think I got one roll of film— that's all I had of him. I remember getting halfway and I still didn't have it, and I was aware that I had six frames left. So you don't waste one. Each one becomes a punctuation mark, a clear, bold moment in the limited event I have with somebody. Frame 6, frame 7, frame 8. By the time I get to frame 10, my assistants know to whisper in my ear, "Three frames left." There might not be another roll. As soon as I take the film [back] off and go to put another one on, there's a break, and with these kinds of people, if they see there's a break, the shoot is over. But while I'm still shooting, they can't interfere. I've still got them. It's such a powerful relationship between me and the sitter. No one would dare interrupt. That moment, with those last three frames, is when it's time to crank things up, and you know this is it.

Film has an essence and tangibility that I still love. It has a little bit more soul for the kind of imagery that I want to make. Film is a lot more robust and has a much

Platon, 2011

broader tonal spectrum than digital. But that doesn't mean it's right for anyone else, and it seems that it's not right for many other people, because I'm one of the last few, apparently, who are using it. When I'm walking around with my two Leica M6s with 3200-speed film in them, I get the craziest looks from the other photojournalists, like, who's the dude with the dinosaurs around his neck? I don't believe in making statements with technique or tools. Content is everything. I have no doubt that eventually I'll go 100 percent digital, but it's not there for me yet. I'm not impressed enough with it, so I'm kind of waiting in the wings.

ELI REED
PHOTOGRAPHER, DISTINGUISHED EDUCATOR

Interviewed June 9, 2012, in Hanover, Maryland

I have been at Magnum Photos since 1983. I was born in London, New Jersey, raised in Perth Amboy, New Jersey. I went to art school in Newark, and then I realized just as I was leaving, after I graduated, that I wanted to be a photographer, so I started just carrying a camera with me. I graduated in '69 from art school. Sixty-eight was a tumultuous year, and a lot of things happening in politics, world history, movies, and the '70s were affected by all these things. My photojournalism has been based on a lot of things—the search for beauty, for reason. I grew up during the civil rights movement—which is still going on, really—and that's bound to make you take things seriously, no matter what discipline you decide you want to go into.

I started out drawing and painting, and so the camera became another kind of paintbrush, and the film became another kind of paint. Some things move on and you just go on, but they don't change in a certain kind of way. You use different tools; they still deal with the visual thing. I even do drawings on my iPad sometimes. I'm taking pictures with my iPad. It keeps on going on.

One thing I find myself doing more and more is that when I'm using a Leica or Nikon or whatever, I will not even pay attention to the light meter. It's like, the lighting is *this*. As long as I don't think about it, it'll be fine. I'll be right on the money, you know? Because you're feeling the light. If you've done it long enough, you really appreciate the light in a certain kind of way. It's like a sensual feeling, like holding hands with a lover, you know, as you move down the street and move through life or whatever,

Eli Reed, 2012

Eugene Richards, 2013

and you'll be—*swish!*—just in, and it'll be right on the money. It's not about someone saying, oh, where's the rhyme or reason? I say, I'm not rhyme or reasons. It's because you have learned your craft enough to know what you're seeing and what you have to do to capture what you're seeing.

So many people have no idea what it takes to bring images that are real, that are important, that move people. Some people's idea of being moved is, look at my navel. Isn't it wonderful? Look at my foot. Isn't it wonderful? And look at the pretty colors on my toenails. Things like that. There's sometimes a reluctance to deal with real issues and the real world. As far as I'm concerned, if your photography has to do with violence or war, conflict photography, when you do work that people are moved by and learn something from, you're not doing something just because you want to be a photography superstar,

but you're doing thoughtful, mind-provoking things. That's where it becomes art. The thing is, you can ignore the world as it is or you can try to engage and do something. "Let truth be the prejudice," as W. Gene Smith stated in his monograph. If you can't stand it, go someplace else. The fact is, the rest of us live in this real world, you know? And there are so many beautiful things.

I love shooting color in digital, but I'd rather shoot black-and-white film when possible. In our present reality in this time and space, everybody is attracted to digital photography because it's so easy, and the camera can lead the way or it can lead you astray. Digital cameras can help you, if you're not stuck in one gear and if you're willing to open yourself up, lose the ego, just go in there. Accept what's going on. See how it applies to you. That's why I'll never get bored. It's a lifelong love affair with photography that will never end.

EUGENE RICHARDS
PHOTOGRAPHER

Interviewed January 4, 2013, at his home in Brooklyn, New York

Digital cameras...I'm not overly fond of them. Mostly because I haven't found a camera yet that I can properly focus, at least with the kind of less-than-perfect eyesight that I have and the very wide-angle lenses that I tend to use. I manually

focus the cameras, often in very low light, since in my experience, autofocusing lenses have a habit of jumping in and out of focus. Another significant problem I have with digital cameras is that I tend to shoot an awful, awful lot of what turn out

Alison Rossiter, 2012

Richard Sandler, 2009

ones and zeroes, and the sense of depth is being mimicked. Still photography on film is the exact opposite. A negative or a transparency actually has thickness. If you look at it in cross section, and magnify it, you see that there are actual varying degrees of thickness in the negative, or in the slide. The gelatin [coating] is made from animal bones and sinews. And so there is something truly organic about film. And that sense of the thickness of the actual material is translatable into the print that it makes. Therefore, an image shot on a negative film, or a positive film, has that sense of depth, has that sense of reality. You can almost taste what life looks and feels like.

Film always looks better, compared to digital. It always looks better to my eye. There's nothing more beautiful than the grain of film. It just has a gorgeous look, and it responds to light, you know, the way a lover responds to your touch. I just don't like the way digital looks. The sharpness is not a problem, there's plenty of visual information there, but it always feels virtual. It always feels strangely unlifelike. I suppose if we didn't have analog photography to compare it to, we would never know that, but we do have analog photography to compare it to. In the printing realm, you can make it

absolutely perfect now with digital photography, and in so doing, eliminate the possibility of surprise and accident. For that reason, I find that analog photography is still superior, even in the printing realm. Picasso could never have made a second painting that was exactly the same as the first one. It's always going to be a little bit different. When I go to my printer, the great Sid Kaplan, every print is different. And he's fond of saying, you know, every one's got something that's just right.

The very medium of film itself is different, content-wise, from digital. It has a different emotion, and emotion is content. So it's not just this benign application of "Should we shoot on a digital still camera, or should we shoot with a Leica with film?" When you look at film, it's just like your heart opens up. You feel it in your heart, you feel it in your gut. You can play around with digital and approximate that feeling, but with film it's always there.

But then again, if I was born 20 years ago, and I'm a 20-year-old kid and I'm just coming up, and all I know is digital photography, I'd probably find the beauty in that as well, and the artistic impulse would be there just the same.

STEVEN SASSON

ELECTRICAL ENGINEER AT EASTMAN KODAK COMPANY (RETIRED), CO-INVENTOR OF THE DIGITAL CAMERA

Interviewed October 17, 2009, in Rochester, New York

George Eastman was amazing, because he single-handedly democratized photography. He went from plates to film, and he was determined to come up with film, even though he had no idea how to do it. And then once he had film, he wanted to lower the price of those cameras. He started out at $25 a camera, and ended up selling the Brownie for a dollar, something like 12 years later. A dollar! I mean, think of that revolution. That made pictures for everybody; that was fantastic. And then he spent the rest of his life trying to get color. He just had this mission to take this really esoteric art form that required tons of equipment—a wagon full of equipment when Eastman was a kid—to something that anybody could do, and it was just amazing to see that he did that in his lifetime.

Film is an incredible technology. It always has been, and it remains that way. Think about it—that little piece of film you can put in your camera. It gets manufactured somewhere; it can be stored on shelves for years, put in a camera, any camera, taken anywhere around the world, and then for a fraction of a second be exposed to light; and it retains that image maybe for years, until it's developed. And then that same piece of film is used for maybe projecting onto a print, right? Well there's no single element in the digital chain that even comes close to what that piece of film does. It's really amazing when you think about it. The electronic approach decomposed the elements of that film into different functions. And all those functions were developed, and a microprocessor came along, digital signal processing, digital memory came along, CCDs came along. So it decomposed that whole chain, you know, made it all come together in the digital camera. But that piece of film did everything, all by itself. You've just got to marvel at that.

I must tell you that as we showed this new camera to management, it really wasn't shown to the highest levels of the company, like the CEO and the upper management people in the Kodak office. I remember hearing second hand that they had heard about the camera and asked about it. And my management chain said, "No, it's really not ready to show you," which I found a little odd, because I felt it worked. But when you go back and you think about it, here we were in a conference room in 1976, and

Steven Sasson, 2009

we were taking pictures without film and we were showing them without prints, no consumables whatsoever. If you're a middle manager, it's not the best way to get invited to a party. I had a whole presentation I routinely did for the management that I was able to demonstrate the system to, but I never got through it all, because there were so many questions. It started with, "Tell me more about this, how did this work?" to "When do you think this will be commercially viable?" I was asked that all the time. Comments, compliments, and criticisms—I got it all. Criticism: Why would anybody want to look at their picture on a television set? How are you going to store these images? I had no answers for any of this. I expected people to ask me how I got such-and-such a circuit to work, because that's what I'd spent my time doing, but no, they were asking me more futuristic questions. I had no idea how fast and how big the CCDs would get. When they told me we'd need between one and two million pixels to create an acceptable consumer picture, I thought it would be 15 or 20 years away, maybe more.

And I don't mean to say that I was the only person thinking about this technology. The people in the research lab were thinking about it. In fact, there was a fellow named Bryce Bayer who came up with the color filter array patent, the fundamental patents used in all cameras today, basically [the Bayer filter]. This is the idea of putting a little color filter array over a CCD to allow it to see in color. And it was very novel, very thought-provoking. He came up with this idea and solved this problem before we ever had digital cameras. But he was thinking about this ahead of time. That was very typical of Kodak.

This thing came together, and it was partly luck and good support on the part of not only Gareth Lloyd and my immediate management chain, but also the people around me. I had so many questions. For instance, I didn't know how to design a lens. I knew I had I had about 12 square millimeters of area on the CCD, and that the image plane of a Super 8 millimeter movie camera was larger than that. So I went downstairs to where we manufactured them, and I lifted that optical assembly out of a waste bin where they were throwing away a broken one. And I brought it upstairs, and we jiggered it in—I put an IR filter to block it off and managed to put the CCD in—and that's my optical design. This is just an example of using the designs of Kodak engineers for a different purpose. So I think this [first digital camera] is really a collection of pieces of technology that a whole bunch of people worked on, and I was in the very fortunate position of being able to sit here and pick and choose among these elements and put them together in a little bit different way, and that was fun.

ROBERT L. SHANEBROOK

WORLDWIDE PRODUCT-LINE MANAGER FOR KODAK PROFESSIONAL
FILMS (RETIRED)

Interviewed October 18, 2009, in Rochester, New York

One project I worked on when I started at Kodak was the Apollo Lunar Surface Close-up Camera that the astronauts took on nearly all the missions to the moon's surface. I did work in liquid crystals, making displays and photographs with liquid crystals in a lab adjacent to where Steve Sasson did the work on the digital camera. I built a three-color liquid-crystal display about 10 inches in diameter. And this was in 1973. Kodak was not particularly interested in electronic imaging at the time, so our funding was drying up. I looked at other opportunities in the company and then went to work in the film business, which I thought would be a better place to be for a career. I worked on X-ray films, when silver was at $50 an ounce. That was a very exciting time. Then I worked on black-and-white films and developed T-Max films. I became the worldwide manager for black-and-white products, and then worldwide manager for Ektachrome/Kodachrome products, and then color negative film. So I was in the worldwide manager role for twenty-some years. In that role, I interfaced daily with manufacturing and research, ran the business, and dealt with photographers, including many of my heroes, like

[Yousuf] Karsh and Ansel Adams, on a number of occasions.

The fundamental materials for making film are a base and emulsion. The film base is either acetate or PET, which is the same material used for pop [soda] bottles. For emulsion, we use cow bones that come from a meat-processing plant to make gelatin. It's a very high-purity gelatin. We use gelatin that's far better than what's used in the food industry. The material that's light sensitive is made up of silver and a halide, a salt. We use silver ingots, 99.999 percent pure silver that comes from a mine in Mexico and other mines. The silver is submerged in nitric acid to make silver nitrate. This is combined with a salt like sodium chloride, bromide, iodide, one of the halides. This is done in the dark, of course. Those materials are combined with over 100 other very pure chemicals, organic and inorganic, and coated on a sheet of film. Coating is done at a high speed, with very high precision, up to 20 different layers of 20 different liquids laid down to a total of 30 microns thick. And then that's cut up and delivered to photographers. Compared to anything else we buy it's probably the

Robert L. Shanebrook, 2009

most sophisticated chemical product you'll find in your home. But Kodak hardly ever dwells on the complexity of the process. The goal is to make it look simple. "You push the button, we do the rest."

In September of 2003 Kodak announced that they were going to reduce development of new color films in the future. I got the message. That was September 1, and I retired October 1. I guess what I would miss most if film was no longer available is the satisfaction of knowing that people are enjoying the century-old effort of Kodak people. I'd also miss the relationships I built up with people, and the pride I had in the films we were making. It would be as though I know a whole lot about something nobody cares about. It would be a personal loss.

It just never occurred to me that it would disappear. Obviously, I started to get the message in the '90s that there was a threat from the development of digital cameras. People right down the hall from me were working on digital cameras, so I saw images and saw their progress almost every day. We considered partial substitution in our planning and strategy meetings, probably beginning in the very early '90s. We certainly didn't have our heads in the sand. But that doesn't mean there was a whole lot that could be done about it. Our management primarily focused on this wonderful technology, silver halide, which is a fantastic technology that we developed. As the expression goes, "When you only have a hammer, every problem looks like a nail."

TARYN SIMON
PHOTOGRAPHER

Interviewed August 31, 2011, at Gagosian Gallery in the Chelsea neighborhood in New York City

I started photographing at a very young age. My first use of a large-format camera was at the Rhode Island School of Design. I worked on 4x5, 8x10, and even 20x24. From then on I needed those shifts of the 4x5 and also the ability to look at the ground glass from a distance and see where the edge of the

frame ends and starts. It's a much more precise and calculated way of looking that I never abandoned.

For a long while, I tried to pretend the transition to digital wasn't happening, because it made the process of making pictures so unenjoyable. But I finally

Taryn Simon, 2011

Eric Taubman, 2011

1920s and 1930s, at the time of the Pictorial and Photo-Secessionist movements. I have lenses from that period by Pinkham & Smith and by Karl Struss, the cinematographer who made his own lenses.

Pinkham & Smith was a company in Lexington, Massachusetts. It was a small company, but it was considered the Rolls-Royce of soft-focus lenses. These lenses are very special. They're not just about overall diffusion. What they do is they create a glow in the highlights, but the shadows are crystal clear. No diffusion in the shadows. So you don't get this overall muddy, fuzzy look. They are really beautiful. The interesting thing about the Karl Struss lenses is that they were the most primitive of all lenses. They're referred to as a simple meniscus,

meaning it was just one piece of glass that was mostly made out of quartz. The Struss lenses really are handmade. They're in these aluminum barrels, and the name is stamped in with a hammer and punch. There's nothing like them.

Regarding artists who choose to work in alternative processes, I've never understood the idea that you can't look back, and that there's this historical progression. That you always have to create something new, as though photographers completely explored these processes back then, and they finished. No, it's not finished; nobody finishes anything. There's a return to these older processes, but with experimentation and exploration, and there are going to be things to find out. There really are.

GEORGE TICE
PHOTOGRAPHER, MASTER PRINTER

Interviewed October 26, 2009, at his home in Atlantic Highlands, New Jersey

I joined the Navy in 1956, and I was discharged in '59. At the time, if you joined before you were 18 you got what was called a "kitty cruise." You got discharged one day before you're 21. So I went in at 17 and a half, and spent three and a half years in the Navy. Right before I was to be discharged, there was an explosion aboard the ship [the USS *Wasp*]. By that time, I was a photographer's mate third class. I took a picture of men pushing burning helicopters overboard, which was sent out over the wire services; it was the front page of the *New York Times*, the *Daily News*, the *Daily Mirror*. It was published all over the world. And then they got a cable from Edward Steichen to the ship—we were about 300 miles out at sea—requesting a print for the Museum of Modern Art's collection. I was 20 years old. I said, I guess I must be an artist. That was my start.

After I got discharged, I bought a used 4x5 Deardorff, but I wasn't satisfied with that for long, and I bought a new 8x10 Deardorff. I've been using that camera since '69; I still use it. The lenses I have are ancient. One lens was made in Berlin before my father was born. The equipment I use I've had for a long time. Like

those 8x10 enlargers, they're made out of wood. There were less than 50 made before World War II. I don't think its design could be improved upon. It can do things that other enlargers can't. The Omega enlarger I bought new in '67. So I know how to work this equipment.

Most of the pictures I take, I use. When I would go out with the 8x10 camera, I used to take one picture if I could afford it, when it was $1 a sheet of film. Now it's about $4 a sheet of film. Now, I'll take two, three, four pictures and I use mostly everything I do, meaning it's usable for a book. And what's in a book is usable for an exhibition. So I have a very high percentage of keepers. Books are the thing that drives me on. It gives me the satisfaction of reaching a greater audience.

I choose to work in black and white because it's as permanent as you're going to get. I mean, the prints will age if you don't process them right; they'll fade. If you don't tone them, they'll silver over like a tarnished teapot. But it all harmonizes, from the black to the white and all of the intermediate shades of gray; it's all in harmony. Whereas with color, you don't choose the colors, and it's not

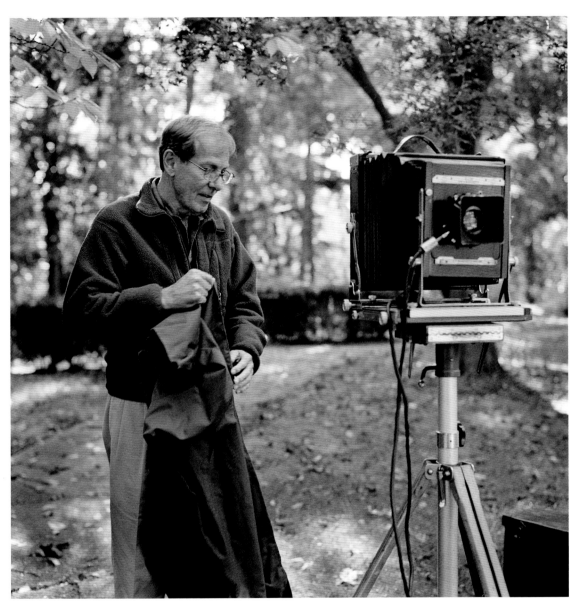

George Tice, 2009

Jonathan Torgovnik, 2009

Alex Webb, 2011

high-quality content in a couple years. It will come to a point there are no budgets to do this. So how are we going to actually produce this work? That's scary. Who is going to pay for producing high-quality, important work? Who? Although the tools we have make it easier for us to do things and produce the work, the distribution and dissemination of this work is lacking. That's what I'm worried about.

Of course, we want to make a living from this, but we really want to create, and we want to do work that's respectful and nicely composed, and make beautiful images and try to connect with the subject. What I see happening in a lot of this work, there's no—it's so cold. There's no connection with the content. There's no connection with the subjects being photographed. It's all about the visual: color and saturation. And that's where the first impact comes to you. It's not from, "Wow, this looks like an interesting person," right? And [the latter] is what I'm interested in. And that's what I'm going to continue to do.

ALEX WEBB
PHOTOGRAPHER

Interviewed December 19, 2011, with Rebecca Norris Webb at their home in Brooklyn, New York

It's been a painful process, the transition to digital, on a number of different levels. There's a psychological, or almost philosophical level, which is simply the intangibility of digital. It really disturbs me that I look at my desk and there are six hard drives, and my pictures are inside. I just was much more comfortable with knowing that there were filing cabinets full of transparencies, and so forth.

There is still a part of me that has some sense of unease about digital, and it's hard for me to get rid of it. Probably if I'd been 75 when digital had emerged, maybe I would've just said, "Look, I'm not going to deal with it." But I like to think I have some years ahead of me for photographing, and I sort of felt, well, I'm kind of a dinosaur, maybe I should try to embrace this new development in this century.

I think whether it's digital or whether it's film, the world only gives you so many interesting pictures, and they just don't come along very often. And when they come along, you may be in the right place or you may not be.

I think that Kodachrome 200 expanded my photographic vocabulary and enabled me to work in certain situations that I couldn't before, and still get a kind of quality that I wanted. In many ways I think digital is expanding this yet further. So there's been a direction—you know, I don't want to just take pictures in "hot light" for the rest of my life. I have interest in some other things. There are other kinds of notes, not just in terms of light, but in terms of mood and emotion, that I think I'm open to, or sensitive to now, that I wasn't then. I'm a different person now, in 2011, than I was in 1979, when I started working in color. I'm not only intrigued by those places that I went to in 1979. I'm exploring other places, too, including the US.

Well, Kodachrome, always said to me, it was the right thing to use in the tropics. I don't know what digital will tell me. We'll see.

REBECCA NORRIS WEBB
PHOTOGRAPHER

Interviewed December 19, 2011, with Alex Webb at their home in Brooklyn, New York

I'm actually in the midst of my digital anxiety, and so am wading very slowly into working digitally. I'm a little wary about making the transition from film to digital, because at heart, I'm a very tactile photographer and bookmaker. I just wonder how much that tactile process ultimately affects my photography, especially those very tactile pauses, like when you load the film, rewind it, take it to the processor, and then pick it up. I also think the waiting may play a larger role in my creative process than I first realized—especially when editing and sequencing prints. One of the reasons I say this is because I'm a writer as well as a photographer, and I've learned over the years that I prefer writing my first drafts out by hand. It's only much later that I type a more finished draft into my laptop. I've come to believe that the pencil and paper are an integral part of my process. So I'm just wading very, very slowly into the digital waters, so to speak.

A portrait of Rebecca Norris Webb and Alex Webb in Cuba while working on their book Violet Isle *(Radius Books, 2009) appears on page 19.*

STEPHEN WILKES
PHOTOGRAPHER

Interviewed November 15, 2012, at his home and studio in Westport, Connecticut

I will use whatever the technology is, or the process is, to help tell the story I want to tell. When choosing between film and digital, I don't let one overpower the other, necessarily. There's still room for film in many things that I do. But my mind-set right now is doing these very, very complex digital photographs [for the project *Day to Night*]. That's not to say that my next project after this couldn't be something that would enhance or embody what they did at the turn of the last century. I'd be fascinated by that. One thing I've just experimented with is taking state-of-the-art digital and melding it with 100-year-old glass. I've had special systems built where I can literally mount an antique lens that has no diaphragm into a housing, and shoot an 80-megapixel back with a glass lens that Steichen or Stieglitz would have used. You can mix and match, too—you can do anything. It's really up to your imagination.

My mastery of film has made me a much better digital photographer. And I think you see relationships between them. For instance, if you can shoot transparency film and nail the exposure, then you're just going to be that much better at

shooting digital. When you go from the ground up, and you start with a roll of film, capturing an image, processing it, and seeing it come to life like that, it affects you in a different way. I don't think that if you just start as a digital photographer you ever truly understand the alchemy of what photography is.

I think this idea of "Well, photography is not really photography anymore, because it's electronic, and it's ones and zeros versus, you know, grain and noise"—I think those people are missing it, in a way. I think we're on the precipice of getting image quality that begins to replicate what our visual experience is when we see. Eventually you're going to see digital cameras that capture information about the amount of depth, highlight, shadow, dynamic range—all those things. The perception of depth, the perception of black, the highlights, and all those things that make a photograph become dimensional are going to get to a level where it's really going to look like a window, I think. And that's very, very exciting to me. Then we start to get to a level of story where a flat piece of paper on a wall becomes something much more than that.

Stephen Wilkes, 2012

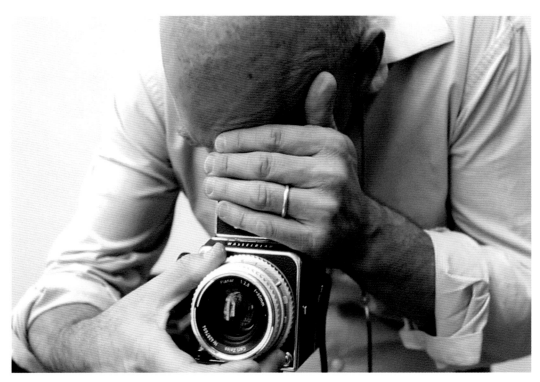

Harvey Wang, 2011

AFTERWORD

Like many photographers I interviewed, I was reluctant to give up film. When digital cameras first came out, I felt the image quality was inadequate. For a while, I shot both film and digital, because I didn't fully trust the new tools. The technology has come a long way. I have confidence in the results I can achieve with digital today. But in some ways, I lost my connection to photography when it was no longer about negatives I could handle and prints I could make in the darkroom. The experience of making a print is, for me, unmatched. I haven't developed a creative connection to the digital work flow yet.

I embarked on this project to see how others fared as photography evolved. In the process, I hoped to clarify things for myself. Part of me wants to stay the course—to go back to photography the way I fell in love with it, and keep on doing what I've been doing. And yet the work being done with new technology is exciting and inspiring.

It's remarkable how digital cameras respond to low and mixed light. And it's comforting to immediately see what you've got. I haven't developed the sort of deep connection to my digital cameras that I have for my late-1930s Leica IIIC,

or my mid-'80s model Hasselblad. I like the pace of shooting with the medium-format camera. It's a slower way to work, and each frame is more precious. I enjoy the challenge of having only 12 frames on a roll of 2¼ film. Digital cameras are very convenient, maybe too convenient for me. And the archiving is an issue. The hard drives and digital files just don't give me the sense of satisfaction that negatives and contact sheets do. I am still working with negatives I made 40 years ago (such as for the cover of this book).

After my mother passed away, I was cleaning out her house and found albums and boxes of photographs from her past. Photographs of the 1939 World's Fair, where she met my father. No one had touched them for at least 50 years. I don't think the next generation will be able to plug in a hard drive they find in a basement 50 years from now and recover that history, at least not easily. One of the motivations for my work is recording my world for the future, so in that sense, digital isn't compatible with what I want to do.

I do think inkjet prints are beautiful. Although they are often the end product of a long digital work flow, they are, after all, just pigment on paper, which

goes back to what artists were using way before photography. I personally don't want to put in the time at the computer to make inkjet prints. For whatever reason, I don't enjoy it. But the results have come a long way and are rivaling the beauty of silver prints.

Many people are dismantling their darkrooms, but not me. I'm looking forward to teaching my youngest daughter and my son to print, as I taught my two grown daughters. It's an opportunity to spend time with them away from a screen, in a quiet place, to show them what's possible when you give yourself the time and space to concentrate, reflect, and master the materials of your craft.

CONTRIBUTORS

Takeshi Akagi was born in Tokyo in 1944. He started to work as a junior camera designer at Yashica before he was assigned to work in the United States. In 1980, he resigned from the camera manufacturer and started his own as camera-service business, establishing Nippon Photoclinic Inc. in 1984 with his partner, Mr. Kobayashi. Akagi retired in 2012. Nippon Photoclinic continues to repair all kinds of photo equipment in New York City but specializes in film and analog equipment.

Adam Bartos was born in New York in 1953. He carries forward the tradition of American vernacular photography, focusing on contemporary landscape. His work is included in the collections of the Museum of Modern Art, New York; the San Francisco Museum of Modern Art; the Stedelijk Museum, Amsterdam; the J. Paul Getty Museum, Los Angeles; and the Museum of Fine Arts, Houston. Bartos is noted for his series *International Territory: The United Nations 1945–1995* and *Kosmos: A Portrait of the Russian Space Age*. His publication *Boulevard* (Steidldangin, 2005) features images of Los Angeles and Paris; his monograph *Darkroom* was published by Steidl in 2012.

Deborah Bell was born in St. Paul, Minnesota, in 1954. She received her B.F.A. in photography from the Minneapolis College of Art and Design and her M.A. in art history from Hunter College. Upon moving to New York in 1978 she worked as a photographer's assistant and printer. In 1984 she joined Sander Gallery, followed by Marlborough in 1985, before opening Deborah Bell Photographs in 1988. She has exhibited and sold works by many important photographers including August Sander, Bill Brandt, Irving Penn, Richard Avedon, Walker Evans, Robert Frank, Louis Faurer, William Eggleston, Diane Arbus, Lee Friedlander, Garry Winogrand, Sid Kaplan, Gerard Petrus Fieret, John Cohen, Peter Hujar, Edward Weston, Josef Albers, Laszlo Moholy-Nagy, and Susan

Paulsen. Deborah closed her gallery in 2011 to join Christie's New York, where she was head of the photographs department through 2013. In 2014 she reestablished Deborah Bell Photographs.

Richard Benson has worked as a photographer, printer, and teacher since the 1960s. He was the dean of Yale University's School of Art from 1996 to 2006. Benson has received two National Endowment for the Arts publication grants (with Eakins Press), two Guggenheim Fellowships, and a MacArthur Foundation Fellowship. In 2008, he curated a large exhibition on the history of printed pictures at the Museum of Modern Art (New York) and authored an accompanying book titled *The Printed Picture*. His photographic work is in the collections of the Museum of Modern Art and the Metropolitan Museum of Art in New York City, the Yale University Art Gallery, and many other institutions and private collections. He shows his work at the Pace MacGill Gallery in New York. Benson currently resides in Newport, Rhode Island, with his wife, Barbara.

Meghan Boody received her B.A. from Georgetown University and was studying at Parsons in Paris when she discovered her love for photography. Upon returning to New York City, she apprenticed with photographer Hans Namuth, chronicler of Jackson Pollock and other noted artists. Soon after, she quickly developed her own voice. Integrating Photoshop and digital compositing into her work in the early 1990s, Boody is considered a pioneer of this new technology. Recent shows include *Radical Terrain* at the Rubin Museum (New York); *Magical Realism* at the Houston Center for Photography; and *Fairy Tales, Monsters and the Genetic Imagination* at the Frist Center for the Visual Arts (Nashville, Tenn.). Her work is in important collections including the Whitney Museum of American Art (New York), the Herbert F. Johnson Museum at Cornell University, and the Museum of Old and New Art in Tasmania.

Mark Bussell is the former picture editor of the *New York Times* and *New York Times Magazine*. He worked with the Museum of Modern Art (New York) to produce the book and exhibit *Pictures of the Times: A Century of Photography from The New York Times* and developed strategies to turn articles from the daily newspaper into the *Times'* first video and web presentations. Mark conceived and edited the award-winning book *Without Sanctuary*, a collection of photographs dealing with lynching in America, and helped organize the accompanying exhibit at the New-York Historical Society. He has curated numerous shows in China and the United States, including the first-ever exhibition on the walls of the Basilica of St. Patrick's Old Cathedral in New York. His clients include Lincoln Center for the Performing Arts, PBS, and Providence Pictures. He currently teaches at New York University's Tisch School of the Arts and writes regularly for the *New York Times* Lens blog.

John Cohen was born in New York City in 1932. He received his B.F.A. and M.F.A. from the Yale School of Fine Arts, where he studied painting with Josef Albers and photography with Herbert Matter. He was a founding member of the seminal folk revival group the New Lost City Ramblers and is a noted photographer and documentary filmmaker. In the 1960s, he worked with Robert Frank during the making of *Pull My Daisy*. Cohen's books include *There Is No Eye* (powerHouse Books, 2001), *Past Present Peru* (Steidl, 2010), *The High and Lonesome Sound* (Steidl, 2012), and *Here and Gone* (Steidl, 2014). For 25 years, he was a professor of visual arts in photography at Purchase College, State University of New York. The Library of Congress has acquired Cohen's archive to make his photographs, films, and recordings accessible to researchers and the public. He is represented by L. Parker Stephenson.

Gregory Crewdson received a B.A. from Purchase College, State University of New York in 1985 and an M.F.A. from Yale University in 1988. His work is in numerous collections, including New York's Museum of Modern Art, Metropolitan Museum of Art, Whitney Museum of American Art, and Brooklyn Museum, as well as the Los Angeles County Museum and San Francisco Museum of Modern Art. His awards include the Skowhegan Medal for Photography, the National Endowment for the Arts Visual Artists Fellowship, and the Aaron Siskind Fellowship. His published monographs include *Hover* (1995), *Twilight* (2003), *Gregory Crewdson from 1985 to 2005* (2005), *Fireflies* (2007), *Beneath the Roses* (2008), *Sanctuary* (2010), *In a Lonely Place* (2011), and *Gregory Crewdson* (2013). He is director of graduate studies in photography at the Yale University School of Art and is represented by Gagosian Gallery.

John Cyr, born in 1981, is a Brooklyn-based photographer, printer, and educator. He earned his M.F.A. from the School of Visual Arts and teaches at the International Center of Photography in New York City. He is the author of the monograph *Developer Trays* (powerHouse Books, 2014). Cyr's photography is represented in many notable public and private collections, including George Eastman House International Museum of Photography (Rochester, N.Y.), the Photographic History Collection at the Smithsonian's National Museum of American History (Washington, D.C.), and the New York Public Library.

Ruud van Empel was born in 1958 in Breda, The Netherlands. He studied at the St. Joost Fine Arts Academy in Breda. His awards include the St. Joost Prize (1981), the Charlotte Köhler Prize (1993), the H.N. Werkman Prize (2001), and the Municipality of Breda Lifetime Achievement Award (2013). He is represented by the Stux Gallery in New York City and the Flatland Gallery in Amsterdam. He works and lives in Amsterdam.

Elliott Erwitt was born in France in 1928. He spent the first 10 years of his childhood in Italy and immigrated to the United States in 1939. He learned photography in a commercial darkroom while attending Hollywood High School. After traveling and photographing in Italy and France and serving

in the US Army, Erwitt was invited by Robert Capa to join Magnum Photos in 1953. In 1968 he became president of the agency for three terms. He has enjoyed a varied career that has included filmmaking as well as photography. The author of more than 20 photography books, Erwitt has had solo exhibitions at venues around the world, among them the Museum of Modern Art in New York City, the Art Institute of Chicago, the Smithsonian Institution, the Museum of Modern Art in Paris (Palais de Tokyo), and the Reina Sofia Museum in Madrid. Elliott Erwitt likes children and dogs.

Jason Eskenazi was born in Queens, New York. He is the author of *Wonderland: A Fairy Tale of the Soviet Monolith*, winner of Best Photography Book 2008 by Pictures of the Year International; *Title Nation*; and *The Americans List*. He has received a Fulbright Scholarship (2004), a Guggenheim Fellowship (1999), the Dorothea Lange/Paul Taylor Prize (1999), and the Alicia Patterson Foundation Grant (1996). His work has appeared in many magazines and newspapers, including *Time*, *Newsweek*, and the *New York Times*, as well as in Soros Foundation publications. Eskenazi briefly worked as a security guard at the Metropolitan Museum of Art (New York), where he created and co-edited an independent magazine for the guards called *SW!PE*, which received much media attention. He is international curator of FOTO Istanbul and was the international curator/creative director for the Bursa Photo Fest during its first two years. Eskenazi also co-founded Red Hook Editions and *Dog Food* magazine.

Alfred Gescheidt (1926–2012) was born in Queens, New York. He attended the Art Students League of New York, the University of New Mexico, and the Art Center School in Los Angeles. Based in New York City most of his life, he had a prominent career as both artist and photographer. His photomontages, ingeniously conceived and created in the darkroom, have been seen worldwide and made him famous, appearing in hundreds of publications, postcards, posters, calendars, and record album covers as well as scores of magazines, such as *Life*, *Look*, *TV Guide*, *Time*, *Esquire*, *Parade*, *Pageant*, *Oui*, and *Playboy*. Gescheidt's work is represented by Higher Pictures Gallery in New York City. For additional information, contact his son, JackGescheidt: jack@JackPhoto.com

David Goldblatt was born in 1930 in South Africa. Since the 1960s has devoted all of his time to photography, founding the Market Photo Workshop in Johannesburg in 1989 to teach photography to young people, especially those disadvantaged by apartheid. In 2001, a retrospective of his work, *David Goldblatt: Fifty-One Years*, traveled internationally. He has had solo exhibitions at New York's Museum of Modern Art, Jewish Museum, and New Museum. Numerous books of his work have been published, and his photographs are in the collections of the South African National Gallery, Cape Town; Bibliothèque Nationale, Paris; Victoria and Albert Museum, London; and Museum of Modern Art, New York. He is the recipient of the 2006 Hasselblad Award, the 2009 Henri Cartier-Bresson Award, and the 2013 ICP Infinity Award.

Ken Hackman is a photographer and trailblazer in military visual information. Enlisting in the US military at age 17, he graduated from the still photography course at Lowry Air Force Base and spent three years at the Yokota Air Base in Japan. He founded the Air Force photojournalism program in 1971 and served as chief of Air Force photojournalism until retiring in 1995. Since his retirement, he has served as director of the annual Department of Defense Worldwide Military Photography Workshop and coordinator for the Military Photographer, Videographer and Graphic Artist of the Year competitions. For the latter, he received the Department of Defense's Exceptional Public Service Award in 2011. He also received the 2013 Joseph A. Sprague award from the National Press Photographers Association. He has been a visual information consultant to the US military since 1988, and he continues to photograph military and civilian assignments worldwide.

Charles Harbutt's pictures have been widely collected and exhibited at institutions including New York's Museum of Modern Art and Whitney Museum of American Art, the Art Institute of Chicago, and in Paris the Centre Pompidou (Beaubourg), the Bibliothèque Nationale, and the Maison Européenne de la Photographie. For the first 20 years of his photographic life, Harbutt was a photojournalist, working mostly through Magnum Photos (of which he was twice president) for magazines in Europe, Japan, and the United States. Since 1980, he has pursued more personal interests to recapture the pleasures of photography for its own sake. Three books and one monograph of his work have been published, including *Travelog* (MIT Press), winner of the Arles award for Best Photographic Book of 1974. He has taught at Cooper Union, Parsons, Pratt Institute, and Bard College as well as in numerous workshops here and abroad. In 1999, he was appointed an associate professor at Parsons, the New School for Design, where he teaches still.

Chester Higgins Jr., born in 1946, is a 1970 alumnus of Tuskegee Institute (University). He has been a staff photographer at the *New York Times* since 1975. His monographs include *Feeling the Spirit: Searching the World for the People of Africa* (Bantam Books, 1994), *Elder Grace: The Nobility of Aging* (Bulfinch Press, 2000), *Echo of the Spirit: A Photographer's Journey* (Doubleday, 2004), and *Ancient Nubia: African Kingdoms on the Nile* (American University in Cairo Press, 2012). Higgins has published and exhibited widely. His work is in many collections, including the Museum of Modern Art and the International Center of Photography in New York, the Library of Congress, Virginia Museum of Art, the Birmingham Civil Rights Museum and Huntsville Museum of Art in Alabama, Brooklyn Museum of Art, Smithsonian National Museum of Natural History, and Detroit Institute of Arts.

Howard Hopwood has worked in the photographic business for 40 years and is chairman of Harman Technology Ltd., the company that bought Ilford Black & White when that company entered receivership in 2004. He began as a research chemist, developing silver halide emulsions, then moved into technical service to support the launch of the world's first chromogenic black-and-white film (a negative containing no silver). After moving into marketing, he established Ilford as the "Best in Black & White." In the 1990s, he became head of worldwide marketing and launched the first Ilford inkjet products. He retired from full-time employment at the end of 2013 but remains chairman of the board. In March 2011, Howard became deputy chair of the Cheshire and Warrington Enterprise Partnership and is active in the areas of innovation, exporting, and marketing.

Jeff Jacobson was born in Des Moines, Iowa, in 1946. He graduated from the University of Oklahoma in 1968 and from Georgetown University Law Center in Washington, D.C. in 1971. Jacobson quit his law practice in 1974 to devote his energies fully to photography. He joined Magnum Photos in 1978 and left in 1981 to help found Archive Pictures. His books include *My Fellow Americans* (University of New Mexico Press, 1991), *Melting Point* (Nazraeli Press, 2006), and *The Last Roll* (Daylight Books, 2013). His photographs are in the permanent collections of the George Eastman House (Rochester, N.Y.), Center for Creative Photography (Tucson, Ariz.), San Francisco Museum of Modern Art, Houston Museum of Fine Art, and Whitney Museum of American Art (New York). Jeff lives with his wife, Marnie Andrews, in Mt. Tremper, New York.

Sid Kaplan, born in 1938, is a master black-and-white printer and photographer from the Bronx, New York. He studied photography in high school at the School of Industrial Art in Manhattan, then honed his craft working in studios and darkrooms in New York City. In 1968, he started his own printing business. He has printed for many of the biggest names in photography, including Edward Steichen, Robert Frank, Weegee, Louis Faurer, Allen Ginsberg, W. Eugene Smith, Cornell Capa, Philippe

Halsman, and Duane Michals. He has taught dark-room printing at the School of Visual Arts for over 40 years. Kaplan has had solo exhibitions in Paris, Minneapolis, Philadelphia, and New York City, and his work is in the collections of the Minneapolis Institute of Art; Art Institute of Chicago; New York Public Library; Museum of Fine Arts, Houston; Museum of Fine Arts, Portland, Maine; and the Museum of Modern Art in New York.

Edward Keating has lived and worked as a photographer in New York City since 1981. After 10 years as a street photographer, he was hired as a staff photographer at the *New York Times*. In 2002, Keating won the Pulitzer Prize for his coverage of the attacks on 9/11. At the *Times*, he also co-founded the Vows wedding column. He has been a regular contributor to the *New York Times Magazine*, *Time*, *Rolling Stone*, *W Magazine*, and *New York Magazine*. His work is in the collections of the Museum of Modern Art in New York City and the Norton Museum of Art in West Palm Beach, Florida. In 2008, Keating exhibited his collection *New York* alongside Robert Frank's *The Americans* in China at the Pingyao International Photography Festival. In 2011, his collection on Route 66 was featured at Bursa Fotofest in Turkey.

Thomas Knoll, born in Ann Arbor, Michigan, received his Ph.D. from the University of Michigan. He co-invented Photoshop with his brother, John Knoll, in the late 1980s. Photoshop 1.0 shipped in 1990. In 2012, after 24 years as a collaborative consultant for Digital Imaging, he joined Adobe as an employee and Adobe Fellow. He also built the Adobe Camera Raw technology and created the Digital Negative file format (DNG). He is an avid amateur photographer and began printing in his father's basement darkroom when he was in high school.

Jerome Liebling (1924–2011) was a photographer, filmmaker, and teacher. In the 1940s, he studied photography under Walter Rosenblum and Paul Strand and joined New York's famed Photo League. His monographs include *Jerome Liebling:*

Photographs 1947–1977 (1978), *Jerome Liebling: Photographs* (1982), *The People, Yes* (1995), and *The Minnesota Photographs 1949–1969* (1997). His many awards and grants included two Guggenheim fellowships, a National Endowment for the Arts Photographic Survey Grant, and a fellowship from the Massachusetts Council on the Arts. His work is in many permanent collections, such as the Museum of Modern Art and the Jewish Museum in New York; Museum of Fine Arts in Boston; Fogg Museum in Cambridge, Massachusetts; Corcoran Gallery of Art in Washington, D.C.; and the National Gallery of Canada in Ottawa. He held professorships at the University of Minnesota in Minneapolis and Hampshire College in Amherst, Massachusetts.

Nathan Lyons has been an integral part of almost every area of photography as photographer, educator, lecturer, author, and curator. He is founding director emeritus of the Visual Studies Workshop (1969–2001) and a distinguished professor emeritus, SUNY Brockport. He holds a B.F.A. in literature from Alfred University and was named an honored educator by the Society for Photographic Education (1997). At the George Eastman House he served as associate director and curator of photography, editor of publications, and director of extension activities (1961–1969). Lyons was a founder and first chairman of the Society for Photographic Education and initiated the formation of Oracle, an annual meeting of photographic curators. He has exhibited extensively since 1956, and his work is represented in numerous collections. His publications include *Notations in Passing* (MIT Press, 1974), *Riding First Class on the Titanic!* (Addison Art Gallery, 2000), and *After 9/11* (Yale Univ. Art Gallery, 2003).

Sally Mann, born in 1951 in Lexington, Virginia, is one of America's most renowned photographers. She has received numerous awards, including NEA, NEH, and Guggenheim Foundation grants, and her work is held by major institutions internationally. Her many books include *Second Sight*

(1983), *At Twelve* (1988), *Immediate Family* (1992), *Still Time* (1994), *What Remains* (2003), *Deep South* (2005), *Proud Flesh* (2009), and *The Flesh and the Spirit* (2010). A feature film about her work, *What Remains*, debuted to critical acclaim in 2006. Mann is represented by Gagosian Gallery and Edwynn Houk Gallery, both in New York. She lives in Virginia.

Constantine Manos was born in South Carolina in 1934 to Greek immigrant parents. He earned his B.A. in English literature from the University of South Carolina and joined Magnum Photos in 1963. Manos is the author of five books: *Portrait of A Symphony* (1960), *A Greek Portfolio* (1972), *Bostonians* (1975), *American Color* (1995), and *American Color 2* (2010). In 2003 he was awarded the Leica Medal of Excellence. His photographs are in the permanent collections of the Museum of Modern Art, New York; Art Institute of Chicago; Museum of Fine Arts, Boston; Bibliothèque Nationale, Paris; George Eastman House, Rochester, New York; Museum of Fine Arts, Houston; and Benaki Museum, Athens.

Paul McDonough was born in Portsmouth, New Hampshire. After high school, he moved to Boston in 1958, where he received his degree from the New England School of Art. He has lived and worked in New York City since 1967. During that time he has worked as a freelance photographer, paste-up mechanical artist, and photography teacher at Pratt Institute, Yale University, Cooper Union, Marymount College, Parsons School of Design, and Fordham University. He has received grants from the National Endowment for the Arts and the Guggenheim Foundation. His work is in a number of public and private collections, including the Museum of Modern Art (New York), New York Public Library, DeCordova Museum (Lincoln, Mass.), Dreyfus Corporation, Lila Acheson Wallace Print Collection, and the Joseph Seagram's Collection. McDonough lives in Brooklyn with his wife and their two children and is currently represented by the Sasha Wolf Gallery.

Susan Meiselas, born in Baltimore, Maryland, in 1948, received her B.A. from Sarah Lawrence College and her M.A. from Harvard University. She is best known for her human rights work in Latin America. Her books include *Carnival Strippers* (1976), *Nicaragua* (1981), *El Salvador: Work of Thirty Photographers* (1983), *Kurdistan: In the Shadow of History* (1997), *Chile from Within* (1991), *Pandora's Box* (2002), *Encounters with the Dani* (2003), and *In History* (2009). In 1998, she developed *akaKURDISTAN*, an online site of exchange for collective memory. She co-produced the film *Pictures from a Revolution* in 2007. Meiselas joined Magnum Photos in 1976. She has received the Robert Capa Gold Medal award (1979), the Leica Award for Excellence (1982), the Engelhard Award from the Institute of Contemporary Art (1985), the Hasselblad Foundation Photography prize (1994), the Cornell Capa Infinity Award (2005), and the Harvard Arts Medal (2011). In 1992, she was named a MacArthur Fellow.

Paul Messier founded his Boston-based art conservation practice in 1994. He has served as an adviser and consultant to numerous collections, among them New York's Museum of Modern Art, Guggenheim Museum, and New York Public Library, as well as the Cleveland Museum of Art, Harvard University, and Yale University. He currently serves as co-director of the FAIC-Mellon Hermitage Initiative in Photograph Conservation, where he has worked as of 2005. His professional activities include volunteer service to the American Institute for Conservation of Historic and Artistic Works, where he served on the board of directors from 2004 to 2009 and founded the Electronic Media Group in 1996. Messier is also engaged in the development of a reference collection of photographic papers as well as independent research and writing. He received an M.A. in art conservation from the State University College at Buffalo.

Alison Nordström is an independent writer and curator specializing in photography. Based in

Cambridge, Massachusetts, she was founding director and a former senior curator of the Southeast Museum of Photography, and senior curator of photographs/director of exhibitions at George Eastman House (Rochester, N.Y.). She has worked with students of photography, art, and photographic preservation at numerous international institutions. Nordström is the author of more than 100 published essays on photographic topics and has curated some 100 photographic exhibitions in nine countries, including *Lewis Hine, Truth/Beauty: Pictorialism and the Photograph as Art, 1845–1945*, and *Ideas in Things: Photography and Materiality*. She is currently consulting curator for international programs at the Griffin Museum and the curator/lead writer for the Dutch project *Photographs After Baldus*; she will curate the 2015–2016 iteration of Fotofestiwal Lodz in Poland. She holds a Ph.D. in cultural and visual studies.

Platon is a photographer whose work has appeared in *Time*, British *Vogue*, *Rolling Stone*, the *New York Times Magazine*, *Vanity Fair*, *Esquire*, *GQ*, the *Sunday Times Magazine* (UK), and the *New Yorker*. In 2007 he was awarded first prize at the World Press Photo Contest for his portrait of Putin in *Time* magazine. He signed a contract to shoot for the *New Yorker* in 2008 and has produced many photo essays, winning two ASME Awards (2009 and 2010). In 2011, Platon received a Peabody Award for his work about Russia's civil society in the *New Yorker*. He has published two books: *Platon's Republic* (2004) and *Power* (2011). Platon has exhibited in New York at the Matthew Marks Gallery, Howard Greenberg Gallery, and the New-York Historical Society, and in Paris at the Colette Gallery.

Eli Reed grew up in Perth Amboy, New Jersey. He attended the Newark School of Fine and Industrial Arts, graduating in 1969. He joined Magnum Photos in 1983, becoming a full member in 1988, following his important early work in Central America. Reed's monographs include his first book, the highly acclaimed *Beirut, City of Regrets*, and

Black in America, his documentation of the African-American experience over more than 20 years, from the 1970s to the end of the 1990s. Reed has lectured and taught at the International Center of Photography in New York, Columbia University, New York University, and Harvard University. He is currently a clinical professor of photojournalism at the University of Texas in Austin and continues to work on visual projects that interest him, including motion picture.

Eugene Richards, an editorial photographer, film-maker, and writer, was born in Dorchester, Massachusetts. After graduating from Northeastern University, he studied photography with Minor White, then joined VISTA and was assigned to eastern Arkansas. He published the first of 17 books, *Few Comforts or Surprises: The Arkansas Delta*, in 1973. Richards's subsequent books include *Dorchester Days*; *Exploding Into Life*; *Cocaine True, Cocaine Blue*; *Stepping Through the Ashes*; *The Blue Room*; *War Is Personal*; and *Red Ball of a Sun Slipping Down*. His work has appeared in magazines worldwide, and he has had more than 40 solo exhibitions. Among numerous honors, he has won a Guggenheim Fellowship, the W. Eugene Smith Memorial Award, the Kraszna-Kraus Book Award, and the Visa d'Or Lifetime Achievement Award.

Alison Rossiter studied at the Rochester Institute of Technology in Rochester, New York, and the Banff Centre School of Fine Arts in Alberta, Canada. She has held teaching positions at the Nova Scotia College of Art and Design and Drexel University, and has been a freelance photographer in the studios of Christie's auction house in New York City. Rossiter spent eight years as a photography conservation assistant at The Better Image, which provided the foundation for her work with expired photographic papers. Her work is in numerous collections, including the J. Paul Getty Museum (Los Angeles), George Eastman House (Rochester, N.Y.), San Francisco Museum of Modern Art, Philadelphia Museum of Art, National Gallery of Art

(Washington, D.C.), and the National Gallery of Canada in Ottawa.

Richard Sandler is a documentary filmmaker and a street photographer. His photographs in the collections of the Brooklyn Museum and the New York Public Library. Sandler was awarded two New York Foundation for the Arts fellowships for photography, and a Guggenheim Fellowship for filmmaking. He is currently working on two film documentaries on the subject of American history as told solely by "American Indians."

Steven Sasson grew up in Brooklyn, New York. He received his B.A. in 1972 and M.S. in 1973 from Rensselaer Polytechnic Institute in Troy, New York. Sasson was hired by Kodak in 1975 as an electrical engineer. One of his first assignments from his supervisor, Gareth A. Lloyd, was to build an electronic camera using the newly invented charge-coupled device (CCD). The resulting invention was awarded US Patent 4,131,919. In 2009, President Barack Obama awarded Sasson the National Medal of Technology and Innovation at a ceremony in the East Room of the White House. The Royal Photographic Society awarded Sasson its Progress Medal and Honorary Fellowship in 2012. Sasson is retired and lives in Hilton, New York.

Robert L. Shanebrook graduated from Rochester Institute of Technology and worked at Eastman Kodak Company for 35 years before retiring in 2003. At Kodak he worked as a commercial photographer, researcher, product development engineer, film manufacturing manager, and, for over 20 years, as worldwide product-line manager for Kodak Professional Films. He was involved in nearly all aspects of Kodak's black-and-white and professional film business. The products included Kodak Tri-X, Plus-X, T-Max, Kodachrome, Ektachrome, Vericolor, Portra, Ektapress, and Pro Films. He is the author of *Making Kodak Film* (2010).

Taryn Simon was born in New York in 1975. Her artistic medium consists of three integrated elements: photography, text, and graphic design. Her photographs and writing have been the subject of monographic exhibitions at institutions including Ullens Center for Contemporary Art, Beijing (2013); Museum of Modern Art, New York (2012); Museum of Contemporary Art, Los Angeles (2012); Tate Modern, London (2011); and Neue Nationalgalerie, Berlin (2011). Permanent collections that have acquired her work include the Tate Modern in London and New York's Metropolitan Museum of Art and Whitney Museum of American Art. Her books and projects include *Birds of the West Indies* (2013–14), *The Picture Collection* (2013), *A Living Man Declared Dead and Other Chapters I-XVIII* (2008–11), *Black Square* (2006–14), *Contraband* (2010), and *The Innocents* (2002). She is a graduate of Brown University and a Guggenheim Fellow.

Eric Taubman is the founder of the Penumbra Foundation and Center for Alternative Photography in New York City. He teaches workshops in wet-plate collodion and in lens history and design. Since graduating with a B.A. from the New School, he has owned and operated a group of photographic laboratory and imaging companies in New York, Los Angeles, Miami, and London. He is an artist and photographer working in large-format and alternative processes.

George Tice, a 10th-generation New Jerseyan, was born in Newark in 1938. He began photographing when he joined a local camera club in 1953. Tice has published 18 books, including *Fields of Peace: A Pennsylvania German Album* (Doubleday, 1970/David R. Godine, 1998, revised), *Paterson* (Rutgers Univ. Press, 1972), *Artie Van Blarcum, An Extended Portrait* (Addison House, 2000), *George Tice: Urban Landscapes* (W.W. Norton, 2002), and *Seldom Seen* (Brilliant Press, 2013). His photographs are included in more than 100 public collections worldwide, and his numerous exhibitions include one-man shows at the Metropolitan Museum of Art, New York (1972), the National Museum of Photography, Film, & Television (now the Media Museum), UK (1990–91), and the International Center of Photography, New York (2002). He has

been awarded fellowships from the Guggenheim Foundation, the National Endowment for the Arts, the Bradford Fellowship (UK), and the New Jersey State Council of the Arts. In 2003 he received an honorary doctorate of humane letters from William Paterson University.

Jonathan Torgovnik graduated with a B.F.A. from the School of Visual Arts in New York. He is the author of two books: *Bollywood Dreams* (2003) and *Intended Consequences: Rwandan Children Born of Rape* (2009). Torgovnik has received many honors, including the 2012 Discovery Award at the Rencontres d'Arles festival, the National Portrait Gallery's Photographic Portrait Prize in the UK, the Open Society Institute's Documentary Photography Project Fellowship Distribution Grant, a Getty Images Grant for Editorial Photography, and the ASMP/PDN Alfred Newman Prize. Jonathan is the co-founder of Foundation Rwanda, an NGO that supports secondary-school education for children born of rape during the Rwandan genocide. He is represented by Alan Klotz Gallery, New York, and for reportage by Getty Images.

Alex Webb is best known for his vibrant and complex color work, especially from Latin America and the Caribbean. He has published 11 books, including *The Suffering of Light*, a collection of 30 years of his color work, and most recently *Memory City* (with Rebecca Norris Webb). Alex has exhibited at museums worldwide, such as the Whitney Museum of American Art (New York), the High Museum of Art (Atlanta), and the Museum of Contemporary Art (San Diego). His work is in the collections of the Museum of Fine Arts, Houston, and New York's Metropolitan Museum of Art, Guggenheim Museum, and Brooklyn Museum. Alex became a full member of Magnum Photos in 1979. His work has appeared in *National Geographic*, the *New York Times Magazine*, *Geo*, and other magazines. He has received numerous awards and grants, among them a Hasselblad Foundation Grant in 1998 and a Guggenheim Fellowship in 2007.

Rebecca Norris Webb has published five photography books, including most recently *Memory City* (with Alex Webb), a meditation on film, memory, and time; and *Alex Webb and Rebecca Norris Webb on Street Photography and the Poetic Image*. Originally a poet, she often interweaves her text and photographs in her books, most notably with her third book, *My Dakota*, an elegy for her brother, who died unexpectedly. Her work has been exhibited internationally, including at the Museum of Fine Arts and Robert Klein Gallery in Boston and Ricco/Maresca Gallery in New York. Her photographs are in the collections of the Museum of Fine Arts, Boston; George Eastman House Museum (Rochester, N.Y.); and Santa Barbara Museum of Art, among others. Her work has appeared in the *New Yorker*, the *New York Review of Books*, *Time*, *Wall Street Journal*, *Le Monde Magazine*, the *Guardian* (UK), and the *International New York Times*.

Stephen Wilkes attended Syracuse University's S.I. Newhouse School of Public Communications. He is a fine art and commercial photographer. Wilkes's projects include *Ellis Island: Ghosts of Freedom* (2006) and *Day to Night*. His awards and honors include the Alfred Eisenstaedt Award for Magazine Photography, Photographer of the Year from *Adweek* Magazine, Fine Art Photographer of the Year 2004 Lucie Award, and the Epson Creativity Award. His work is in the permanent collections of the International Museum of Photography at the George Eastman House (Rochester, N.Y.), Houston Museum of Fine Arts, Jewish Museum of New York, Library of Congress, and numerous private collections. Wilkes is represented by Peter Fetterman Gallery (Los Angeles) and the Monroe Gallery of Photography (Santa Fe, N.M.).

ACKNOWLEDGMENTS

There would have been no book (or film of the same name) if it were not for the participation of the photographers and others who gave of their time to share their stories and wisdom—to everyone who sat for my camera, I thank you. The initial support for this project came from the Alfred P. Sloan Foundation, and I am grateful to Doron Weber, VP Programs and Program Director, for taking an early interest in it. This project could not have been realized without the support of the Center for Creative Photography at the University of Arizona in Tucson, which will become the repository of all my interviews. Essential support came from The Adobe Foundation; my longtime collaborator and friend David Isay; The Better Image; Constance Brinkley and Lynne Honickman, all of whom share my love for the practice of photography.

I am especially grateful to the mentors, friends, and colleagues whose ideas and enthusiasm kept me going, especially Richard Sandler, John Cohen, Jim Mairs, Alison Rossiter, Katharine Martinez, Debra Hess Norris, Nora Kennedy, Peter Mustardo, Eric Taubman, and Geoffrey Berliner.

The first half of this book closely follows the film *From Darkroom to Daylight*, currently in post-production. It was edited by Edmund Carson, who worked tirelessly and with great insight and skill. I am thankful to Derek McKane and the other cinematographers and crew who helped to capture all the wonderful interviews excerpted in these pages. They are: Theresa Alessio, Gabe Deloach, Paul Forgét, Kevin Jones, Dave McGrath, Anthony Milio, Bob Richman, and Aimee Thomas, with production assistance from Devin Yalkin, Kirstin Roby, and Saskia McKane. Special thanks to editors Krystal Lim and Dave Kausch for their work and advice in the early stages of the film; to Jeet Baidyaroy, Stephen Greenberg, and Jesse Maynard for their amazing music; and to Production Junction for in-kind support with video equipment and production services.

I am grateful to the Audio Transcription Service of Boston for transcribing the interviews, and to Laura Panadero for audit-checking them. Thanks to Lesly Deschler Canossi and Andrew Buckland at Fiber Ink Studio, Brooklyn, for film scanning, and to the Daylight Books team for seeing the potential of this book—founders Michael Itkoff and Taj Forer, designer Ursula Damm, and copy editor Elizabeth Bell. I am also grateful to Philip Turner for his important feedback on the manuscript at an early stage, and to everyone who gave valuable input at my preview event at UnionDocs Center for Documentary Art in 2013.

Along the way, many people provided valuable assistance and advice. Among them were Michael Belfiore (Loews Regency Hotel, New York), Nick Bogaty, Carroll Bogert, Roger Bruce and George Eastman House, Nanne Dekking, Jaime DeMarco, Chris Edwards, Billy & Beth Feehan, Maurice Fisher, Jack Gescheidt, B. Winston Hendrickson (Adobe), Howard Hopwood and the staff at the Ilford production facility, Shirley Isaacs, Jeff Jacobson, Sue Jaye Johnson, David Lerner (Tekserve), Frank Ligtvoet, Robert Maass, Scott Moyers, the Metropolitan Museum of Art, the New Museum, Alison Nordström, Eli Reed, Alison Rossiter, Kate Sekules, Stux Gallery NYC, Eric Taubman and the Penumbra Foundation, Lissy Vomáčka, Sasha Wolfe, and the photo group: Juliana Beasley, Mark Bussell, Vincent Cianni, Jessica Dimmock, Jason Eskenazi, Donna Ferrato, Lori Grinker, Keri Pickett, Ken Schles, and John Trotter.

I am always thankful to my parents Edna and Leo Wang, who supported my love of photography when they were alive, and to my children, Sakira, Sophia, Lela, and Leo, who have provided me a lifetime of subject matter. I'm grateful to Libero Arcari for being the perfect mentor when I started my journey as a photographer. There is one person who has given me unwavering and selfless support for as long as I can remember, and that's my friend Robert Balsam. His advice and encouragement have been guiding forces in my life.

I am most indebted to Amy Brost, my wife, and co-author/co-producer of this project. Her brilliant mind and laser focus saw this project through from inception to fruition.

Last but definitely not least, another nod to photography in the digital age. I am honored to acknowledge the following contributors who supported this project on the crowdfunding platform Kickstarter.com:

The Better Image, Constance Brinkley, Anonymous, Lynne Honickman, Bill & Barb Sippel, Francine Horn, Ned Rothenberg, Paul Messier, Andrew F. Green, David Dunbar, Bob Graubard & Abby Gruen, Cameron & Jackie Wilson, Bob & Roberta Fisher, Craig Hofheimer, Bud Glick, Liz Sak, Yuval Segal, Joan Morgenstern, Billy & Beth Feehan, Rex Baldwin, Fran & Skip Eichler, Matthew Johnson, Andrew Gescheidt, Boaz Harrosh, Steve & Mary Coplan, Roberta Grobel Intrater, Kathryn Kerl Brugioni, Sharon & Del Zogg, Yair Reiner, Jerry Clements, Daisy Wright, Vincent Cianni, Esther Cohen, Jeffrey Skoblow, Ethan Swan, Lori Silverbush, the McKane Family, Rob Radtke, George Tice, Mario Breitbarth, Rob & Siobhan Feehan Miller, Bruce Wodder, Declan and Taylor Friedman, Tom Ashe, Mo Ogrodnik, Denise and Jim Landis, Lissy Vomáčka, Scott Moyers & Kate Sekules, Toni Fitzpatrick, Steven Koves, Patrick Russell & Family, Matt Duncan, Carroll Bogert, Dave Isay, Michael Bailey, Kathleen Chalfant, Tanya Silas,

Julia Mayo Johnston, Eddie Rosenstein & Family, Ann Magnuson, Martha Hodes, Nic McPhee, Andy Guidinger, Dog Days Films, Stuart & Melanie Cohn, Suzanne Kessler, Wendy McKenna, Jonathan Soffer, Geoffrey Berliner, Cliff Sloan, Maya Grobel & Noah Moskin, Elaine Smith and Steve Ajl, Richard Heitler & Tamar Rogoff, Ariel Kessler, Stuart and Catherine Rome, Famous Photographers Archive LLC, Joshua Radu, Devin Yalkin, Barbara N. Brown, Eve Mayberger, Eva-Maria Kunz, Maggie Wessling, Grace & Jim Protos, Susan Meiselas, Andrew Swee, Catherine Lukaszewski, Shannon O'Hara Photography, Becky Burcham, Debra Hess Norris, Hanako Murata, Cooper Clan, Marion Lipschutz & Terry Purinton, Ellen McNeilly, John Custodio, Howie Shneyer, Steven Hager, Sylvia Yalkin, Janet Guillet, Donna Day & Justin Henderson, Larry & Hiromi Grobel, Taina Meller, Marie Perry, Michael May & Rachel Proctor May, Stephanie Cohen, Pete Sillen, Eamonn Vitt, Kevin Sweeney, Greg Miller, Daniel Stern, Ken Winber, Sue Jaye Johnson, Malaika Kamunanwire Prosper, Jackie Gill, Sophia Wang, Ray Iannicelli, Tony Iaccio, Brian Storm, TimHGuitar, Shannon Walker, Philip S. Turner, Bob Falls & Sharon Lund, Alexander Heilner, Catherine Rutgers, Stephanie Burchett, The Beck/Jones Experience, Chris Klein, Annika Finne, Matthew Ozug, Peter Helenius, Séra Ing, and thank you to those who just put in $1 or $5. because every bit truly counts.

ABOUT THE AUTHORS

Amy Brost is currently an Andrew W. Mellon Fellow pursuing graduate degrees in art conservation and art history at the Conservation Center, Institute of Fine Arts, New York University. Her interests include technical art history and the conservation of photographs and electronic media art.

Edmund Carson is a film editor living in New York City. He studied film at Bard College and has since worked on several feature documentaries, including Rick McKay's *Broadway: Beyond The Golden Age* (the sequel to *Broadway: The Golden Age*), *Visions of Mary Frank* by John Cohen, and *Don't Think I've Forgotten: Cambodia's Lost Rock & Roll* by John Pirozzi.

Harvey Wang studied visual arts and anthropology at Purchase College, State University of New York. He has published six books of photography including *Harvey Wang's New York* (1990) and, with co-author David Isay, *Flophouse: Life on the Bowery* (2000) and *Holding On: Dreamers, Visionaries, Eccentrics and Other American Heroes* (1995). Wang has exhibited widely at museums, including the National Museum of American History at the Smithsonian Institution in Washington, D.C., the New-York Historical Society, and the Museum of the City of New York. In addition to his portrait photography, he has exhibited work from his life in New York City, particularly in the East Village in the 1970s and 1980s.

IMAGE CREDITS
(photographs by Harvey Wang except where indicated)

Cover: Detail from Self-portrait, Rosedale, Queens, 1973; Pages 2, 10, 11, 13, 20, 23, 24, 31 (right), 34, 35, 38, 44, 45, 48, 53, 158: From the documentary film *From Darkroom to Daylight* (2014) directed by Harvey Wang; Page 6: Self-portrait, Rosedale, Queens, 1973; Pages 8–9: Harvey Wang's darkroom, Brooklyn, New York, 2012; Page 10: Reel with film after development; Page 11: Harvey Wang's negatives of Sophia; Page 13: Harvey Wang's negative of Sally Mann in the enlarger (top) and dodging and burning during printing (bottom); Pages 14–15: Rochester, New York, 2012; Page 17: Daguerreotype from the collection of Eric Taubman; Page 19: Portrait of Alex Webb and Rebecca Norris Webb, Havana, 2003, by a Cuban photographer whose 1903 camera uses a paper negative (Courtesy of Alex Webb); Pages 20 and 23: Photographic paper boxes from the collection of Alison Rossiter; Page 24: Gevaert sample book from the collection of Paul Messier; Page 27: Ilford's first vehicle, a Foden steam wagon, ca. 1905; Pages 28–29: Leo in pixels, 2014; Pages 31 (left) and 32: Photographs from a technical report Steven Sasson wrote in 1976 (Courtesy of Steven Sasson and Kodak); Page 31 (right): First digital camera prototype, 1975, photographed in Rochester, New York, 2012; Page 34: Adobe Photoshop, Macintosh version 1.0.7 splash screen on a Macintosh SE30 computer; Page 35: Adobe Photoshop, Macintosh version 1.0.7, Levels dialogue; Page 37: Stephen Wilkes in Washington, D.C., January 21, 2013, by Alex Abdalian (Courtesy of Stephen Wilkes & Alex Abdalian); Page 38: Ruud van Empel manipulating his work in Photoshop (top), and the artist in his studio in Amsterdam, 2010 (bottom); Page 41: Lela's eye in Photoshop, 2012; Page 42: Sakira's feet in Photoshop, 2014; Page 44: Alfred Gescheidt holding *U&lc* magazine spread Alfred's Asterisks; Page 45: Gescheidt holding a print of one of his *Asterisks* series; Page 46–47: Lela with Leica IIIC, Prospect Park, Brooklyn, 2009; Page 48: Richard Benson working at his inkjet printer, Newport, Rhode Island, 2012; Page 51: Highway map of Arkansas, Skelly Oil Company/Diversified Map Corporation, 1968; Page 53: Chemicals in Sally Mann's studio, 2012. All portraits in *Perspectives on the Digital (R)evolution* by Harvey Wang.